COLOR MIXING

The Van Wyk Way

A MANUAL FOR OIL PAINTERS

Books By Helen Van Wyk

Casselwyk Book On Oil Painting

Acrylic Portrait Painting *(out of print)*

Successful Color Mixtures

Painting Flowers The Van Wyk Way

Portraits In Oil The Van Wyk Way

Basic Oil Painting The Van Wyk Way
(revision of Casselwyk Book On Oil Painting)

Your Painting Questions Answered From A to Z

Welcome To My Studio

Welcome To My Studio *(new revised edition)*

Color Mixing In Action

My 13 Colors And How I Use Them

COLOR MIXING
The Van Wyk Way
A MANUAL FOR OIL PAINTERS

Helen Van Wyk

Art Instruction Associates, Sarasota, Florida
Distributed by North Light Books, Cincinnati, Ohio

COLOR MIXING THE VAN WYK WAY
A Manual For Oil Painters by Helen Van Wyk

Paperback edition copyright © 2000
by Art Instruction Associates

First published in hardcover, copyright © 1995
by Art Instruction Associates

Published by Art Instructions Associates
5361 Kelly Drive, Sarasota, Florida, 34233

Parts of this book were published earlier as
COLOR MIXING IN ACTION and MY 13 COLORS
by Helen Van Wyk

ISBN: 0-929552-18-0

06 05 04 03 7 6 5 4

Distributed to the book trade and art trade in the U.S. by
North Light Books, an imprint of F&W Publications
4700 East Galbraith Road, Cincinnati, Ohio 45236
tel: 800-289-0963, 513-531-2690

Edited by Herb Rogoff

Design & Production by Stephen Bridges

Photography by Anthony Tassarotti

Additional photography by Clark Linehan

Project Coordinated by Hand Books Press
2 Briarstone Road, Rockport, MA 01966
tel: 978-546-3149, e-mail: handbooks@adelphia.net

Printed in Hong Kong

Contents

Introduction

It was during the late forties that I studied with M. A. Rasko. I went to his studio in New York City three mornings a week. He was not only a beautiful painter but a wise, well educated and very dear man. Some years earlier Rasko had an article published in *Design* magazine. Since that particular issue of the magazine is out of print, and since, I believe, the magazine is defunct, I would like to bring some excerpts to you through this introduction. In these excerpts you too will realize how fundamental his approach to painting was:

"Let's face a few basic facts. If we are to produce 'art' in terms of the two-dimensional surface expression, we ought to realize, first of all, our limitations.

"Imagination is definitely not limitless. Nothing enters the human mind for knowledge or conclusions, which are passively retained or put into action, without first having been experienced through one of our five senses. If you, as an artist, are engaged in producing a two-dimensional surface expression, regardless of your medium, you must have first had some contact with what you are trying to express.

"Of all our senses, sight is the most aware. Sight warns us of danger, stimulates our appetite, influences our sensations of touch and smell, and helps translate the sounds we hear. But even the marvelous organ which is our eyes has its limitations, we can see intelligibly to a limited distance; we cannot distinguish objects without light being present; and can perceive only the three primary colors and their complementary colors which originate from sunlight.

"Most important to an artist is that we can see only the five different shapes that nature has created. These shapes are the sphere, the cube, the trihedron, the cone and the cylinder. Regardless of what we see, all shapes stem from these five, no more and no less. It required a Plato to first understand this and put it down, and until the relative present, nobody has sought to refute this law of nature, except the modernists.

"We should not lose sight of the limitations that exist under nature's ordered plan. No human can see colors that are not there; he cannot invent new shapes. At best, he can only combine, rearrange and vary the combinations of these physical factors. Nature has created and man must imitate, even if poorly by comparison. And it is the artist who enacts this important role, for until he translates an experience into a visible interpretation, it cannot exist for the viewer.

"Just how good or bad this interpretation may be depends simply on the artist's ability, dexterity or facility with a material. When we come face to face with these absolute limitations on perception and translation, we must then face an inescapable conclusion: all two-dimensional surface modes of expression, though limited, remain, short of language itself, the best means of communicating with our fellow man.

"Never underestimate the challenges of nature as it exists; there is far more than a lifetime of experimenting for any artist who would seek to catch nature with his brush. And there is mental stimulation in this struggle to express yourself. The thinking and dexterity which are necessary to produce even a poor expression is still a worthwhile manifestation of an individual's intellect. It makes little difference whether art is practiced by an adult or a child—just so long as it expresses something valid, the degree of excellence is of no consequence."

Dear Rasko alerted me to the seven components of the two-dimensional surface expression. They are:

1. Motivation
2. Composition or design
3. Shapes or drawing
4. Tonal contrasts
5. Brushwork
6. Lines or edges of shapes
7. Color

They are the foundation of my painting and my teaching of painting. I define them and teach how they are the working parts of every painting's appearance, regardless of subject matter.

I stress that of the seven components, color is one that can be omitted without diminishing the possibility of pictorial self expression. Then why an entire book on color mixing? Because you can't ignore its existence. We can be emotionally and visually impressed by artists' etchings, engravings, sketches and tonal renderings, but when we see black and white reproductions of paintings, we feel cheated and denied of the element of color. When Mallory, the famous mountain climber, was asked why he climbed Mt. Everest, his answer was "because it's there." And that's the same answer to the question, "Why an entire book on color mixing?"

Color is a glorious part of our existence, and to record it at all means to record it as convincingly as we see it in nature and as beautifully as we are impressed by it. Nature's color is translated by artists with color mixtures, and they actually execute and create our paintings. Those other six important components are hiding out in color mixtures, only to be unleashed onto a canvas by applications. So this book on color mixing becomes necessary. I'm sure it will help you to see colors with more understanding and enable you to mix and apply colors with more satisfaction and success.

Helen Van Wyk
Rockport, Massachusetts

Preface
A More Practical Color Wheel

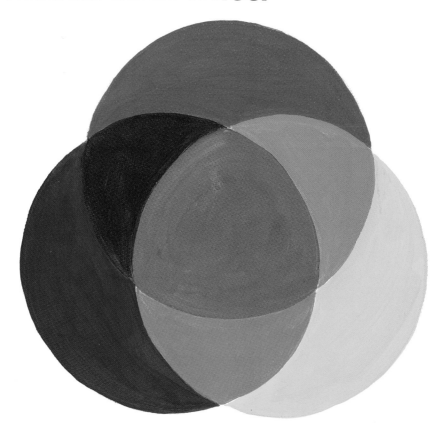

In order to make your color mixtures as beautiful and as natural looking as you see them, you have to learn, and appreciate, the character of color. Your study doesn't have to be scientific or even profound, just a simple understanding of the very presence of color.

Let's start with the painter's *three primary colors: yellow, red, and blue*, as seen in my version of a color wheel (in the physicist's "color wheel," the primary colors are *magenta, yellow-green, and turquoise*). Where these colors meet and mix, three other colors appear. They are *violet, green and orange*, and are called, for obvious reasons, the *secondary* colors.

In the center of this strange-looking formation, we see colorless gray. This is the area where the three primaries meet and mix. The light we see by and the lighting that affects everything we see is a mixture of the three primaries. The choice of gray to represent the ever-presence of the three primaries is a compromise between color in light and color in paint. In light, the three primaries make light; in paint, the three primaries combine to make dark.

What does all this have to do with color mixing?

It's fundamental. Nature's light is made of three colors and they influence everything we look at. If nature paints her world with three colors, we have to use three colors, too. We do so by using a color with its complement.

Red's complement is green, the mixture of yellow and blue.
Yellow's complement is violet, the mixture of red and blue.
Blue's complement is orange, the mixture of red and yellow.

You can see that a color plus its complement is a combination of the three primary colors. All three are needed to record nature's balanced color.

When a color is not balanced, it looks wrong, harsh, flat, or unnatural. Our record on canvas of nature's balanced colors can be made by using this formula: Balance a color with its complement. Used in concert with each other, they will pay a compliment to each other and to your painting. All the chapters in this manual point out the use of colors and their complements and how they record subjects realistically.

Warm and Cool Color

yellow {

orange {

red {

violet {

blue {

green {

We have all experienced the joy of seeing a rainbow. It's a time when nature proves that light is made up of color. When we see a rainbow, we can only see the front half of it. Actually, a rainbow is a circle of color and that's why the spectrum colors are always diagrammed in the form of a wheel, putting colors and their complements on opposite arcs of the wheel.

This diagram of the spectrum starts with yellow, orange and red—the warm colors—and continues to violet, blue and green—the cool colors. Warm yellow's complement is cool violet; the complement of the hottest color orange—is the coldest color—blue; and warm red's complement is cool green. In color mixing, it's important to be able to recognize the temperature of a color because a color that is too hot or too cold is a wrong mixture. Colors with their complements strike the balance of temperature that color mixtures need to be natural looking.

This is all well and good, you may say, but how do I fit it into practical application? It appears that all of this has nothing to do with making grass color, skin color or sky color, to name a few. I cannot predict, imagine, or know what subject you want to paint, or how you want to interpret your subjects, nor do I know what light you'll see your subjects in. How then could I think that just giving you color mixtures would be sufficient color mixing instruction? Learning the principles of color will help you make your own color interpretations instead of relying solely on color formulas. All of my suggested color mixtures should act only as guides not as absolute color solutions.

Dimensionalizing Your Color

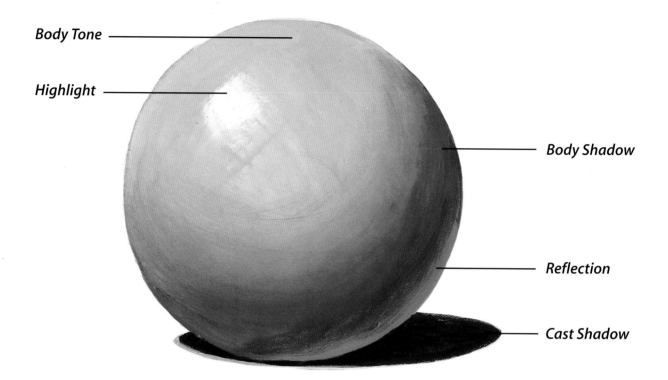

Body Tone

Highlight

Body Shadow

Reflection

Cast Shadow

Light in this world has *three major characteristics*. You have just learned that light is our *source of color*. Another important one is that it *travels in a straight line*. If it didn't, it would be able to go around a corner, thereby robbing us of the contrast of light and shade. Finally, the factor that seems almost too obvious to mention but is so important to pictorial interpretation: in our world we have *only one source of light*. Just imagine how different everything would look if there were two suns coming up every day, one from the east the other from the west. Aren't you glad that you only have to learn how to paint the contrasts caused by *one* source of light that travels in a straight line?

One source of light makes five tone values appear. Seeing how they affect a ball is the best way to begin an appreciation of how important they are in painting. Being able to recognize and paint the five tone values caused by one direct source of light is the way to impose this three-dimensional world on a two-dimensional surface.

Every single area of a painting should simply be one of these five tone values. All these values have to be colored. The tone of a color is the most important consideration in color mixing. If the tone is not right, the color will look wrong. You have to address your color mixtures to record the tone the color happens to be in its lighted or shaded condition.

> Throughout this book, I constantly use the names of the five tone values to describe areas of coloration. Sometimes, I'll use the term **mass tone**; it refers to a subject's general, overall color. A mass tone establishes a shape on which a body shadow can be added with a darker tone, and a body tone can be imparted by adding a light tone. I have been known to say, "You can paint anything dimensionally by massing it in (in a beautiful shape) and adding lighter and darker tones to it."

The Colors of My Palette

You have just examined the properties of the colors of nature. Now I'm going to tell you about the properties of the paint you'll use to record them.

I think it's a miracle that we have physical substitutes for colored light. Ever since the cave man, stuff has either been found or made that can emulate the effect of transparent light rays.

The six colors of the spectrum—yellow, orange, red, violet, blue, green—form the classification of all the tubes of paint that you can buy. There are many to choose from. The paint version of these six colors, and admixtures of them, vary in three ways: **tone, intensity,** and **hue.** In *tone*, from light to dark; in *intensity*, from bright to dull; and in *hue*, which I use to explain that all six colors of the spectrum can tend towards its neighboring color. For instance, yellow can tend toward green or toward orange, and red can tend toward orange or violet. The hue of a color determines, too, its temperature: a greenish yellow is cooler than an orangey yellow, and a reddish orange is warmer than a reddish violet. Recognizing these *three factors of color* is important to mixing colors correctly.

Even if you squeeze out a little of every tubed color available, you still could not make your mixtures actually become the color of the things you see. You have to rid yourself of that impossible assumption. Once you realize it, you are no longer inhibited, intimidated or afraid of mixing colors. Instead, you can be inspired to search out mixtures that might look, and work, well together. Color mixing, after all, is not a definite science; it's an experimental process that produces a color presentation.

From all the tubed colors in the market, I have chosen these colors for my palette because they are not only adequate but efficient as well.

	
White	A lightening agent for all colors
Thalo Yellow Green Cadmium Yellow Light Cadmium Yellow Medium	A range of cool to warm bright, light yellows
Cadmium Orange Cadmium Red Light Grumbacher Red Thalo Red Rose	A range of warm to cool bright, light reds
Yellow Ochre Raw Sienna Light Red (English Red Light)	Darker, duller versions of the warm colors— yellow, orange, red
Burnt Umber Burnt Sienna Indian Red	Even darker, duller versions of the warm colors, yellow, orange, red
Alizarin Crimson Manganese Violet Thalo Blue Sap Green Thalo Green	A range of dark but brilliant cool colors—violet, blue, green
Ivory Black	Used with white to make tones of gray

Some Tubed Warm Colors

Shown here are warm tubed yellows, oranges, and reds that offer an adequate range of tone from light to dark, and intensity from bright to dull.

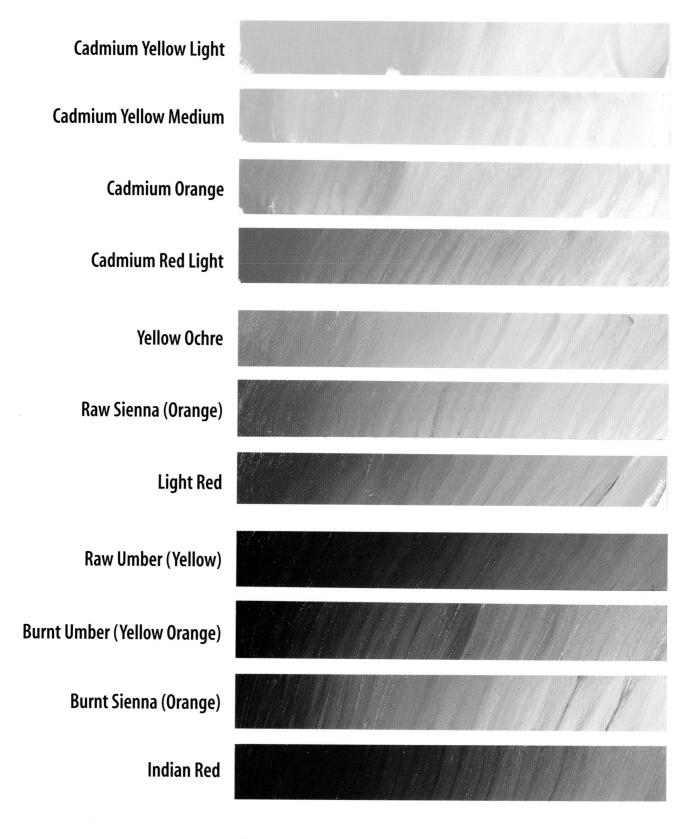

Cadmium Yellow Light

Cadmium Yellow Medium

Cadmium Orange

Cadmium Red Light

Yellow Ochre

Raw Sienna (Orange)

Light Red

Raw Umber (Yellow)

Burnt Umber (Yellow Orange)

Burnt Sienna (Orange)

Indian Red

Shown here are cool tubed violets, blues and greens. Tones of cool colors are made by their admixture with white. Their intensities are controlled by their admixture with gray.

Some Tubed Cool Colors

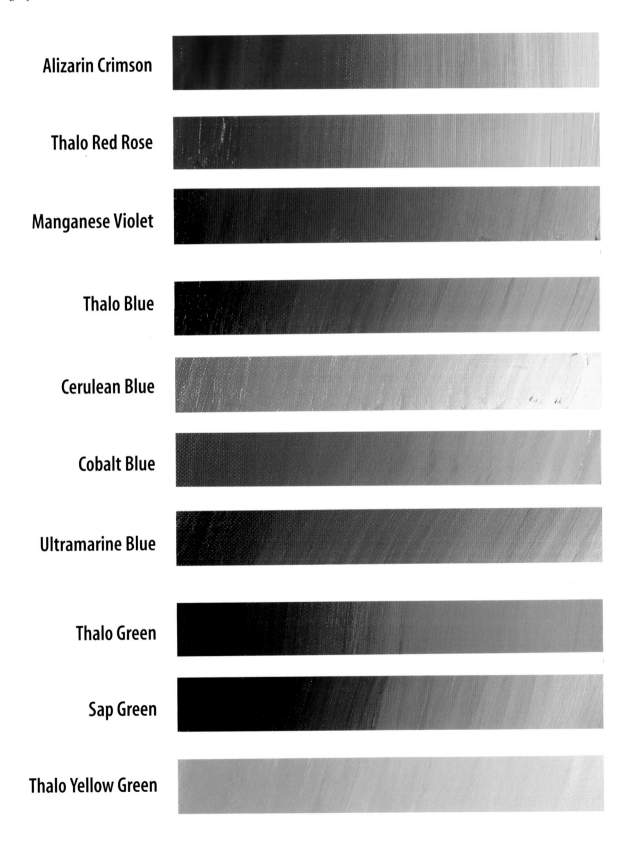

Alizarin Crimson

Thalo Red Rose

Manganese Violet

Thalo Blue

Cerulean Blue

Cobalt Blue

Ultramarine Blue

Thalo Green

Sap Green

Thalo Yellow Green

Materials

A trip to an art supply store for people who have decided to try their hand at painting can be an unnerving experience. The aspiring artists will be greeted by two or three racks of oil paints from different manufacturers, many with names they had never heard before. They will then have to choose their brushes. Their first problem: should we get bristles, red sables or synthetics?; then, what shape? Bright, flat, round or filbert? Finally, what size? Small, medium, large, extra large?

Just when they think their visit is over, they realize that they haven't settled on their painting surface: pre-stretched canvas or canvas boards. And finally, they need a palette.

I will ease the burden for you by simplifying the process of outfitting your studio. Consider this your art material primer; as basic as "See Spot run." In your enthusiasm, don't buy more than I suggest. By the way, people who have already started to paint should pay heed; among students I have taught, I have seen extraneous useless, brushes, duplicate tubes of color and frightfully expensive colors that will never be used.

My list of necessary supplies:

Palette: A varnished piece of wood, 12" x 16". Don't be talked into any paper peel-off palettes.

Palette of colors: Tubed colors that make up the basic, reliable range for mixing the colors in nature. These include Cadmium Yellow Light, Cadmium Orange, Cadmium Red Light, Grumbacher Red, Yellow Ochre, Raw Sienna, Venetian Red, Burnt Umber, Burnt Sienna, Thalo Blue, Thalo Green, Alizarin Crimson and Thalo Yellow Green.

Black and white paint: Any white will do. Make sure you buy the large size of white (popularly called a "pound" size). Make sure the black you buy is Ivory Black.

Canvases: Use stretched canvas or canvas panels. Both come in a variety of sizes. Working on a toned canvas makes painting easier. In a small bowl, mix black and white acrylic paint with some water. With a rag dipped into this gray mixture, cut down the white of the canvas to a medium gray.

Paint rags: Old towels cut into 6-inch squares are the best. Don't use paper towels. They can't regulate the wetness or dampness or amount of paint on your brush as well as a rag can.

Odorless paint thinner: Half fill a large can (one-pound coffee tin) for cleaning your brush between mixtures.

Linseed oil: To mix with turpentine (don't mix with paint thinner) to make a medium (half and half). Use a short, wide-mouthed jar, like one for peanut butter. Always cap your medium when not in use.

Easel: To prop your canvas to an upright position.

Spotlight: To light the subject.

Brushes: My *Overture* and *Finale* brush selections have five brushes in each set. These sets will get you started.

For the more experienced painters, maybe the above list will help you realize that you may be bogged down with too much stuff.

THE "IN-THE-BEGINNING" OF COLOR MIXING

Now that you have become acquainted with the *basics of color*, don't let them overwhelm you. As is true when mastering anything, color mixing, too, can be learned in simple stages. The best place to start being better "color mixers" is to learn a way to mix the right color of things, such as skies, skin, trees, apples, sunlight, and on and on. The *way* is to sneak up on a good mixture, one that records the important color characteristics of a subject's appearance. Let's take them one at a time.

First, you have to see all the colored things in this world as versions of the *spectrum colors*. Many of these are obvious: *Blue* sky, *red* apple, *yellow* lemon. Many objects, however, are not colored as obviously. Identifying them as spectrum colors, then, is more difficult. For example, what spectrum colors are the following: Copper, wood, skin, silver, rust, rocks, sand, clouds? You *have* to record them as colors because your palette does not have *copper* color, *wood* color, *rust* color, etc. Your palette only has *versions of spectrum colors* on it, and these objects' colors are hiding out in them. Copper is an *orange*; wood is a *yellow*; rust is a *red*. As painters, you must identify your subjects' colors. That's a beginning.

Next, you have to inspect the *tone* of the color that you have decided the subject is, meaning how light or dark the subject's color looks in its surroundings.

Another consideration is the color's *intensity*, which describes a color as bright, brilliant, dull or drab. Students often confuse intensity with tone, but when you realize that a color can be light and *bright*—like a lemon—or light and *dull*—like yellow beach sand— you'll refrain from making this mistake.

The final characteristic to analyze about a subject's color is its *hue*. This is the subtlety of the color. To illustrate, a flesh color that is orange in color, light in tone, medium bright in intensity, can be reddish in hue or more yellowish in hue. The hue of a color also describes its temperature. An example of this is a yellow brass color that is greenish in hue is *cooler* than yellow brass that looks yellow-orange in hue.

By defining the four characteristics of a subject's color, you will be able to mix a suitable color. You'll have to ask yourself four questions when faced with painting any subject. Here they are:

1 **Q.** What color do I see?
A. It has to be one of these six:
Yellow, orange, red, violet, blue or green.

2 **Q.** What tone is the color?
A. It is light, medium or dark in contrast to its surroundings.

3 **Q.** What intensity is the color?
A. It is bright, medium or dull.

4 **Q.** What hue is the color?
A. It is a warm version of the color or it is a cool version of the color.

I often use the color yellow to show you how this *way* of color mixing works, since yellow is such a prevalent color. I hope you'll understand that yellow is everywhere, from wood to blonde hair, from sand to bare trees, from gold to an old, tear-stained love letter.

The 4 Questions Illustrated

The color swatches on this page will help you answer the four questions that can guide you to a correct mixture for the little painting of a lemon on a table against a background (shown at right).

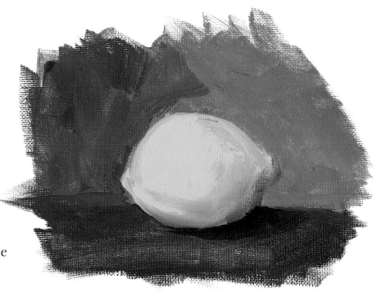

QUESTION 1. What basic color do you see?
ANSWER: Versions of yellow, orange or red, violet, blue or green. In the case of the lemon painting, you see versions of yellow. Even though you are tempted to use words such as brown, rust, tan, or wood color, the lemon is yellow, on a yellow table against a yellow background.

QUESTION 2. What tones are the yellow colors?
ANSWER: The lemon is a light tone in relation to its medium toned background and the dark-toned table. However, against a white background, the lemon color would be called a medium, dark yellow compared to the white background.

QUESTION 3. What are the intensities of the lemon, background and table?
ANSWER: The light-toned lemon is also bright; the medium-toned background is a dull yellow; the table is also dull but darker than the background.

QUESTION 4. What hues are the lemon, background and table?
ANSWER: The lemon is basically Cadmium Yellow Light that is light in tone, its intensity is bright, its hue tends toward green. The background is dull but medium in tone. You could mix its color by adding Burnt Umber into gray made of black and white. The table color is a yellow, dark in tone and its hue is more orangey than the neutral background color. Its color is made by mixing a dark yellow (Burnt Umber) and adding it into some orange (Burnt Sienna) and a gray made of black and white.

Asking yourself these four questions will soon become instinctive just as typists have trained their fingers in relation to their keyboards and pianists think in terms of notes and keys.

You'll see the colors on your palette as possible mixtures of tones, intensities and subtle hues that hit the subjects' colors right on the head.

The Use of White in Color Mixing

Many people come to the study of painting with misconceptions about color. What's more, they try to use these misconceptions to mix color. How I wish I could erase these distorted ideas, and have students use color as a practical way to record an artistic point of view.

The first thing I have to do is to clarify that the whites in nature are really *colored*, and that white paint is not a color. The seemingly light colored things that we paint, such as snow and white china, are always being influenced by a lighting condition that imposes a color upon them; whites, therefore, can be yellow whites or blue whites. No more can the term "off white" be used since "off white" isn't a color. White paint is not white things. It is used in admixture with color to record the beauty of white things.

White is also used to lighten colors because lighter tones of colors are seen where subjects are in light. These areas are what I refer to as *body tones* and since most, if not all, body tone mixtures are lighted areas of objects, white paint is the foundation of the mixtures.

You will not be able to appreciate the importance of white in color mixing without recognizing the basic character and importance of the body tone. Its *importance* is that it is one of the five tone values that makes things look real and round on the flat surface on which you paint. The body tone's *character* is such that it's where the light affects it directly; its color, as a result, has to be lightened with white.

White is also necessary in recording highlights, another tone value that bestows dimensional and textural effects to your painting. You can see now that white is important to the implementation of two of the five tone values.

The other three tone values—body shadow, cast shadow and reflection—also rely on the use of admixtures of white. I will discuss this use in subsequent chapters. For now, I want you to examine white in body tones and in highlights.

Where there's Light there's White

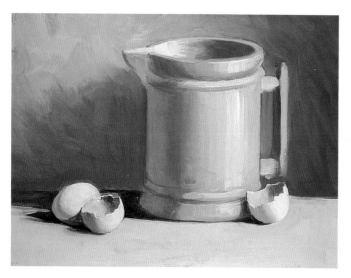

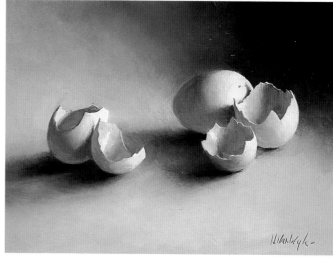

for white things ▲

You can learn two valuable color lessons by painting a white subject: 1) most body tones are made of colors mixed into white; 2) all white things are not pure white.

▼ for highlights

Highlights on objects are not pure white either; they are white with a breath of the object's complementary color. Highlights on the green bottle: white and a little red; the amber (orange) bottle: white and a touch of blue.

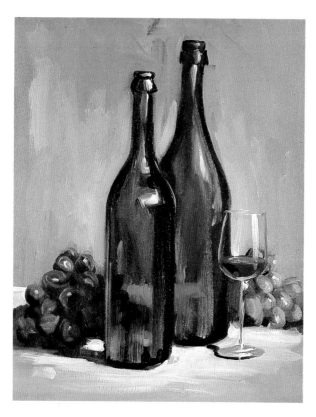

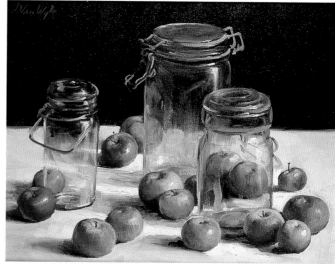

helpful hint
Don't make body tones so light that highlights won't show up.

Flavor Your Color—Warm or Cool

You don't have to use radically different colors to flavor your color presentations. Instead infuse your reaction to warm and cool into your color mixtures. To illustrate, I wanted **warm tones of white** to portray the Roman monk's old worn robe. On the other hand, I thought that Sheila's stylish dress should be **in cool tones of white**. The cool swatch on the left of the monk shows the mixture I used for his shadowed robe; on the right are mixtures for the lightened robe. The color swatch on the left of Sheila's portrait are the darker background tones of the portrait; the swatch on the right shows the mixtures of the light tones of her dress.

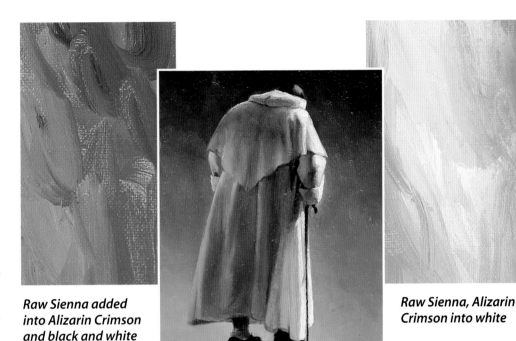

Raw Sienna added into Alizarin Crimson and black and white

Raw Sienna, Alizarin Crimson into white

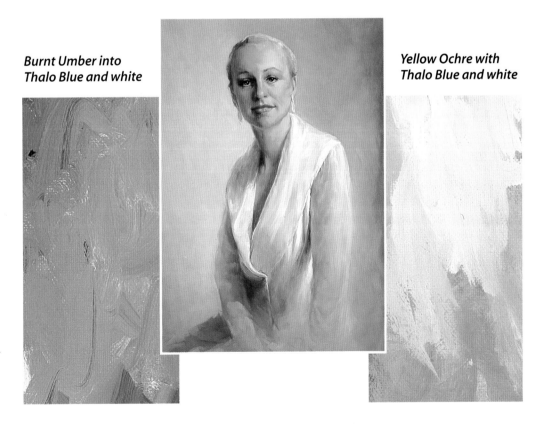

Burnt Umber into Thalo Blue and white

Yellow Ochre with Thalo Blue and white

The Wide Use of the Yellows

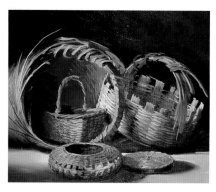

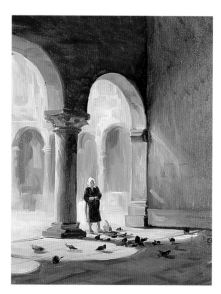

The **color band of yellows** *(right)* will help you understand the difference between tone and intensity. A to B shows yellow ranging from bright to dull with little change in tone. C to D shows yellow ranging from light and intense to dark and intense.

Melissa's hair *(upper left)* is yellow (Yellow Ochre and white, Cadmium Yellow Light and white). The background is yellow, too. On the left, it is dark and grayed, on the right, light and grayed (Burnt Umber into tones of black and white).

The **two bigger baskets** *(middle left)* are medium intensity, light yellows (Yellow Ochre, Cadmium Yellow Light and white). The smaller baskets are orangey–yellows (Yellow Ochre, Burnt Sienna and white).

The **soft yellow sunlight** *(lower left)* in the painting "Feeding Pigeons" is a mixture of white, Cadmium Orange and Yellow Ochre.

Yellows:
Tones
Intensities
Hues

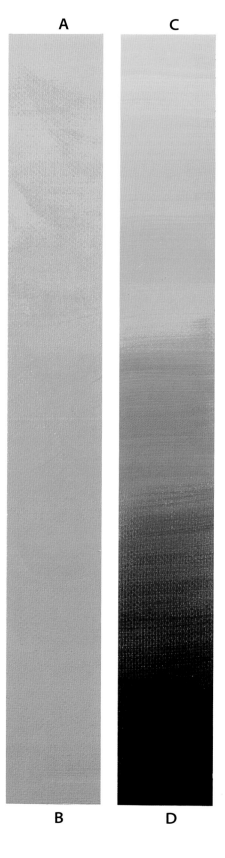

A C

B D

The Comfort of Warm Colors

Individual, good-looking color mixtures are really quite easy to make. It's **how** color mixtures act together on a canvas that presents color problems. Colors in compositions won't clash if you make them all the same type of color presentation, such as all warm or all cool. This picture's green background (a cool color) has been warmed so that it wouldn't clash with all the warm–colored subjects.

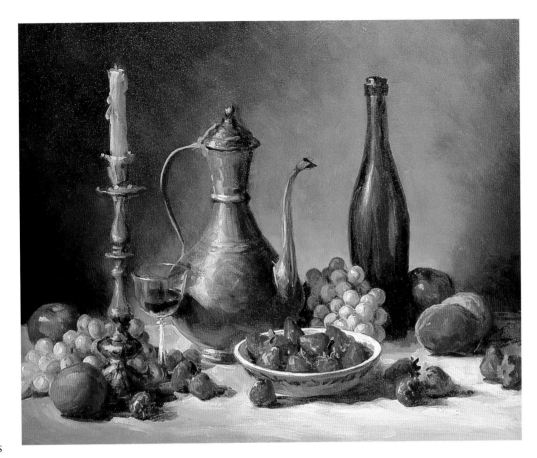

The chart below shows the warm colors—yellow, orange and red—in ranges from light to dark. If white were added to each band, the tones would be lighter and their intensities would be duller. Duller, dark tones could be made by mixing them with a dark gray. This is a good exercise for you to do to acquaint yourself with the warm colors.

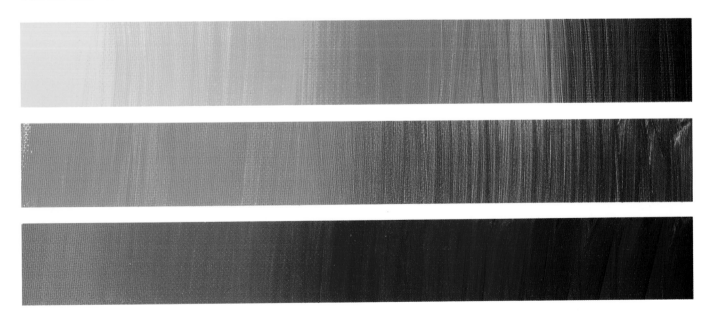

The Other Warm Colors: Orange and Red

The warm colors of the spectrum are yellow, orange and red. Many versions of these colors are seen in nature. How handy it is for us that there are so many tubed versions too! Take yellow, for instance. We have Cadmium Yellow Light, Cadmium Yellow Medium, Yellow Ochre, Raw Umber and even Burnt Umber. I've heard it asked, "Why do we need all these yellows when there is only one yellow in the spectrum?" In nature, there is a myriad of yellows, all from the one that's present in light. For us to paint *all* the yellows we see, we need *more* than one, the ones that give us a chance to mix a full range of tones and intensities of yellow.

Yellow is a primary color, as you well know, which means that it can't be made by using other colors. This is also true of primary red. We are lucky to have a variety of red paints too. The ones that offer us a chance to paint the beautiful reds we see are: Cadmium Red Light, Grumbacher Red, Light Red (also called English Red Light and not to be confused with Cadmium Red Light) and Alizarin Crimson. You'll notice that I have included Alizarin Crimson here as a red while also listing it with the cool colors as a violet. Alizarin Crimson, you see, is a red when it is *mixed with other reds*. It is a violet when it is *mixed with tones of gray*. Yes, it is a versatile color, one that I find indispensable.

Orange colors can be made by mixing yellows and reds, but it is handy to have the tubed oranges on your palette: Cadmium Orange, Raw Sienna and Burnt Sienna.

Body tones of yellows, oranges and reds are relatively easy to produce because they already have the warm color of light. Warm light, shining on a warm color, is easy to mix by adding white into any of the warm colors.

A reminder: the cool colors (violet, blue and green) are the warm colors' complements and should be relied upon to shadow the warm colors. Bear in mind that this doesn't mean that you can dip into any violet, blue or green to do so. The type of complement that you have to use is one that will darken the color and reduce its intensity. To illustrate, Alizarin Crimson is a violet but you can't use it to "shadowize" yellow. You have to mix a gray shadow tone (black and white) and add Alizarin Crimson to it.

THALO YELLOW GREEN

A light yellow that's greenish in hue begins my palette of colors. Why Thalo Yellow Green? Not because of its importance but its light tone and bright coloration is more closely related to the other bright colors of my palette than to the dark colors at the other end of my chromatic lineup. Working with color can be compared to tasting food. You don't know its flavor until you taste it. You won't know a color's flavor until you mix it into white paint. Thalo Yellow Green gets more and more yellow as it is mixed with amounts of white. Excellent for sunlight shining on green grass. When mixed with Thalo Green or Ivory Black, it makes natural looking yellowish greens. This yellow green paint is made by a number of manufacturers, who label it with their own names. The one I use I've had on my palette for many years.

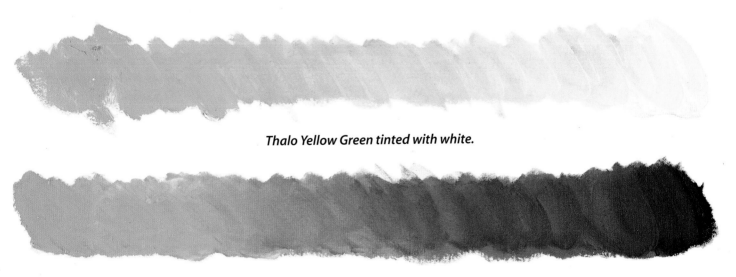

Thalo Yellow Green tinted with white.

Thalo Yellow Green darkened and grayed with Alizarin Crimson and black.

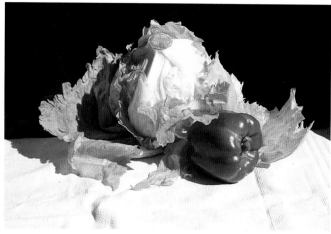

Figure 1

Step 1

Step 2

FIGURE 1. A good example of the use of Thalo Yellow Green is lettuce, which provides, as well, a challenge to your brush to record the ripply leaves. I arranged a dark green pepper against the light-toned lettuce to add some interest to the composition.

STEP 1. Place and proportion the lettuce to your canvas's size and make some lines to guide you with the shaping in of the lettuce. Use Ivory Black greatly thinned with turpentine (or odorless paint thinner). **Don't** add white to the black to lighten it. It will make it thick and hard to cover with color. Don't use charcoal either; it will dirty your colors. If you are afraid of using black, sketch in the lettuce and pepper with thinned Thalo Yellow Green.

STEP 2. Before starting on the lettuce, paint in a dark background tone.

STEP 3. With gray made of black and white, thinly mass in the dark areas of the lettuce. Do it very broadly. Don't get involved with little shapes.

STEP 4. After painting the white part of the lettuce with lots of white, a little Thalo Yellow Green and Burnt Umber, paint in the color of the lettuce where you see it light by adding more Thalo Yellow Green to the previous mixture. As you see the leaves get greener, add a touch of Thalo Green and Cadmium Yellow Light, or use just Sap Green.

STEP 5. Overlap the darker lettuce mixture in the shadowed areas. For the shadows, mix Thalo Green, Raw Sienna, Alizarin Crimson and a touch of Ivory Black and paint in the shadow areas, blending it into the lettuce color.

STEP 6. Mix a fresh mixture of Thalo Yellow Green and white and add it to form the light crinkly leaves that overlap the shadows. This mixture should not be thinned. With that mixture loaded on the front edge of a flat brush, add the light that hits the edge of the leaf

A good rag can regulate the wetness and amount of paint on your brush.

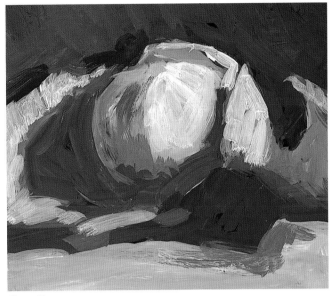

Step 3

that is in the shadow area. I'm sorry that this is a rather complicated shape. To begin your masterly control of your paint applications, use the following procedure to load your brush (you will need the assistance of a rag to regulate the wetness and amount of paint on your brush):

1. Mix quite a lot of the Thalo Yellow Green and white.

2. Wipe the brush clean of the paint that resulted from mixing.

3. Now dip and scoop some of the mixture onto the end of the brush. Wipe one side of the brush on the rag so the brush is loaded only on the end and a bit on the other side.

4. Now pat the canvas with the loaded side. Don't stroke it on, lay it on in many pats, each time replenishing the brush following #3 procedure.

5. If these applications are too wide a shape on the canvas, the result of a heavy hand, cut them down with a brush that you have wiped clean of paint.

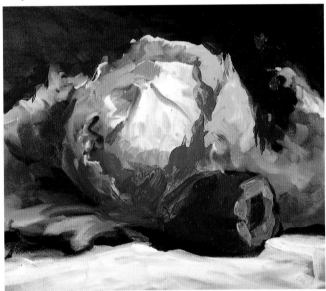

Steps 4 & 5

STEP 7. Do the green pepper (Thalo Green and Yellow Ochre) making it vaguely disappear into the lettuce. Then, re-mass the general coloration of the leaf that falls on the pepper and add the lighter yellow green mixture.

STEP 8. Use the finished painting shown on page 26 as your guide or, better still, do the whole lesson with your own real live lettuce-and-pepper-setup. By comparing my painting, with the actual subject (page 24) you can see that I've taken liberties to make my interpretation more typical of "lettucedom."

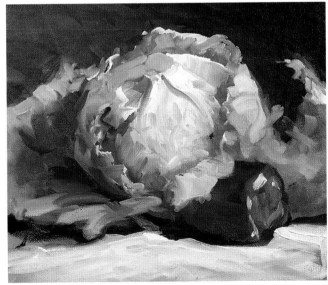

Steps 6 & 7

The Finished Painting

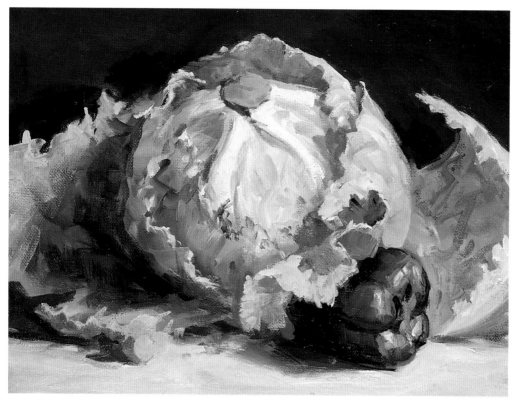

Step 8

The subject of lettuce. The focal point or center of interest of the painting begins at the floppy leaf between the green pepper and the light leaf membranes. This focal point is located on the right-hand third of the canvas and where the one source of light is directed.

Pears, 20 x 30. Another example of the use of Thalo Yellow Green. The pears are the center of interest which, in this picture, is on the left-hand third of the canvas where the lighting comes from the left.

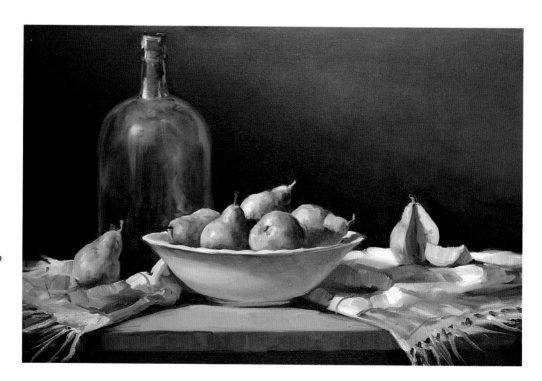

CADMIUM YELLOW LIGHT

Cadmium Yellow Light is the most versatile yellow to use because its hue is the closest one to primary yellow. Zinc Yellow is somewhat greenish and although I do have Cadmium Yellow Medium on my palette, you can very well record the color yellow without it. I chose to paint lemons as the subject for Cadmium Yellow Light not only because they are fun to paint and make a charming little picture, but I also can stress the technique and necessity to paint in an overlapping fashion. Why? The rinds of a cut-up lemon are so much a part of the lemon's structure they can't be considered details that are merely added as finishing touches with a small brush. Pay attention to the steps that show the progression of the applications of paint as well as the color mixtures.

Cadmium Yellow Light tinted with white.

Cadmium Yellow Light darkened and grayed with Alizarin Crimson, black and white.

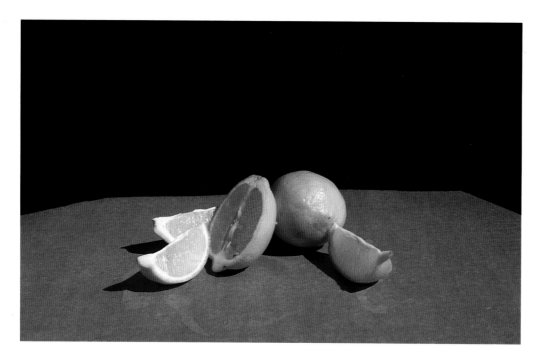

Figure 1

FIGURE 1. The setup. Notice how the arrangement of the wedges shows off the semi-transparent quality of the lemon's pulp and how all the elements of the composition overlap one other. This not only unifies the composition and gives it variety, it also helps depict the depth dimension of the arrangement. Don't put yourself at a disadvantage by trying to paint an arrangement that doesn't clearly illustrate the characteristics of its subject.

STEP 1. When placing the element of your composition on your canvas, always judge its position and size in relation to your canvas's size. Actually indicate your decisions by marking off how close the arrangement is going to encounter the canvas's edges.

STEP 2. The drawing of the subject is simply stated by filling in two values of gray acrylic: one for the table tone, one for the background.

STEP 3. Now, using oil, repaint in the background color: black, white, Yellow Ochre. Don't make these mixtures thick. Thin them with medium so the grayness of the underpainting can influence the color. Let your eye be the judge. Now start the coloration of the whole lemon and the half lemon.

DIAGRAMS A & B. I've made these diagrams to show you how to make the thin white rind. This technique will help you make small shapes of very light tones. Many students try to stroke on thinned whitened areas with a small pointed brush. The white paint in a light passage always makes the mixture thick, and thinning it makes it ineffectual. Paint this white line of rind by putting it in with a bold amount of light paint that records the top shape of the rind, then push the darkened lemon color up into this white area, thus cutting it down to its desired thickness (or thinness).

Here are the color mixtures for the lemons: **Body tones:** Cadmium Yellow Light, Yellow Ochre and white. **Body shadows:** Add more Yellow Ochre and some black and Alizarin Crimson to the body tone. **Rind:** White and a little Yellow Ochre. **Pulp:** Raw Sienna into the body shadow mixture.

STEP 4. The finished painting (page 30). You will notice that the shapes were more carefully defined and the light yellow areas were lightened even more with white and Cadmium Yellow Light. This arrangement of lemons makes a nice little painting as well as being an interesting color exercise. The composition is very basic in that all the pieces of lemons join up to make one shape, each playing a role in defining the characteristic of lemons. Notice the reflection in the shadow of the slice on the right. One good compositional rule to adhere to is: never paint anything "face on". This rule applies to houses and faces as well. Why? Your subject will look flat on the canvas because you are looking at their flat view. Always try to see two planes. Notice how the depth dimension is suggested by the front and side planes of the lemons.

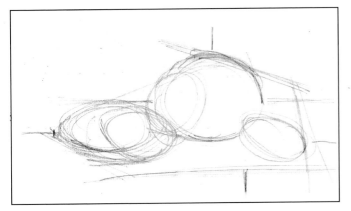

Step 1

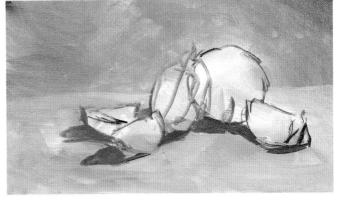

Step 2

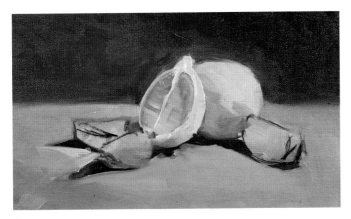

Step 3

> *Never rush to the painting stage. The planning and composition stages initiate a good picture.*

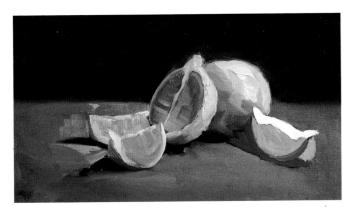

Diagram A

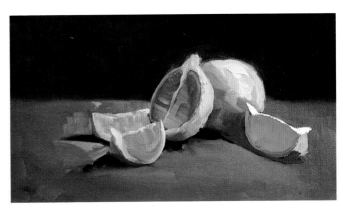

Diagram B

The Finished Painting

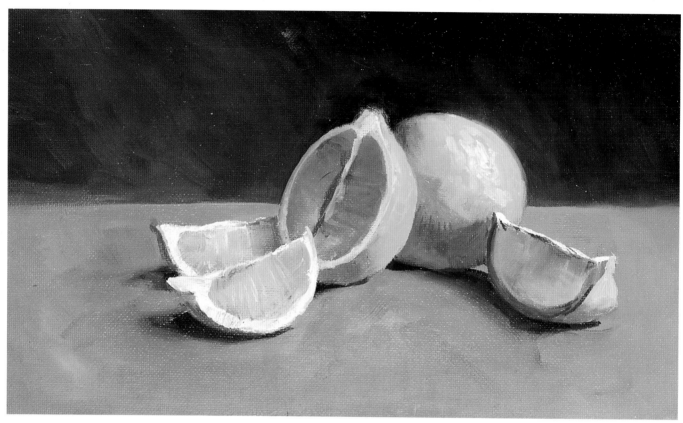

Step 4

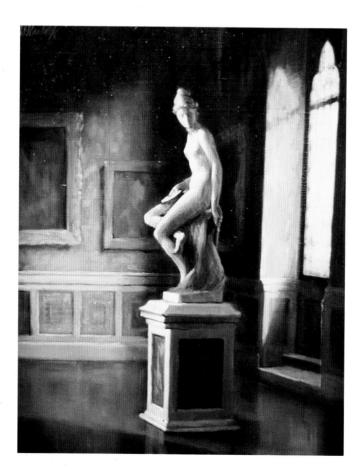

Statue in Bargello, 9 x 12.
The glow of sunlight
shining into the interior
of the gallery couldn't
be done without using
Cadmium Yellow Light
in admixture with the
darker yellow and orange
colors: Raw Sienna and
Burnt Sienna.

CADMIUM ORANGE

Cadmium Orange's characteristics are easy to recognize. It is as bright and light as an orange (the fruit) where it can even be used almost straight from the tube. But its true value is in admixture with other colors. Cadmium Orange can be relied upon to brighten flesh mixtures and to brighten the orange color of copper. It is also a good color for landscape painting because mixed with Thalo Green, it makes natural looking greens. Mixed with white, it could be the color of white clouds. Cadmium Orange helps Cadmium Yellow Light with white in highlight mixtures for gold objects and can be used in the mixture that can add lights to red hair.

Cadmium Orange tinted with white.

Cadmium Orange darkened and grayed with Thalo Blue, black and white.

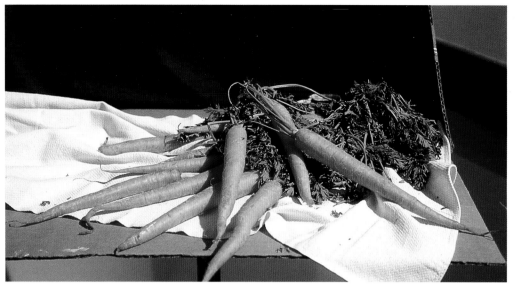

Figure 1

Recording a subject should not outweigh your artistic arrangement of a subject.

FIGURE 1. I thought a painting of carrots would do justice to Cadmium Orange and give me an opportunity to stress another important brush maneuver, that of painting in layers of opposite brushstrokes.

FIGURE 2 is a diagram of the focal area of the still life setup (Figure 1). The center of interest starts at "A" and continues to spread out towards the edges of the canvas. Notice how the arrangement of the carrots forces you to look first at the focal point. Again, the center of interest is on the right-hand third of the entire bunch which is closer to the source of light. Notice, too, how the carrots in my painting (Step 5 on page 34) extend beyond the canvas's edge. I did this to show the earthy casualness of the subject. It's okay to let subjects extend beyond the edges of the canvas but it's not wise to let only one thing extend out beyond one edge of the canvas. Doing so will tip the composition off balance. By going beyond all the edges, the composition maintains a balance and can be accepted as part of the compositional scheme.

STEP 1. With thin gray tones of acrylic black and white, I broadly suggested the background tone and the white towel, which originally was not going to extend down to the bottom of the canvas. Some lines indicate the carrots.

STEP 2. Next, I simply massed the carrot area, in brushstrokes that recorded their length, in Cadmium Orange, Cadmium Red Light, and a bit of light gray (black and white). With Burnt Umber into Thalo Green and Yellow Ochre, I massed the green area.

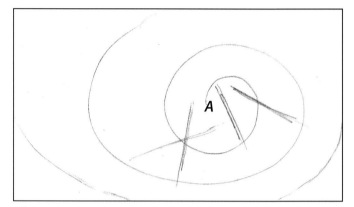

Figure 2

STEP 3. I turned the mass tone color of the carrots into shadow by adding more Cadmium Orange and more Cadmium Red Light to overtake the white in the mixture, and added some Burnt Sienna and Thalo Blue.

STEP 4. I lightened the carrots with a mixture of very light gray (white and a breath of black) and Cadmium Orange. I applied this less intense orange color with a series of short across-strokes that described the carrots' widths not their lengths. The combination of the two-direction application helped to indicate their basic shapes, and their roundness.

STEP 5. You can see by my finished picture (page 34) that I accented the greenery with Thalo Green and white and fixed the carrots' shapes with their cast shadows, made of black, white, Thalo Blue and Burnt Umber. Most compositions and drawings can be improved

Plan a simple design.

Step 1

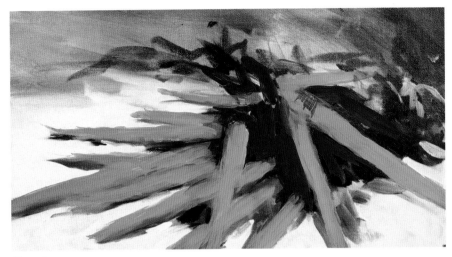

Step 2

Here is a practice you could employ to find a way to use descriptive brush strokes: With a brush in mid-air, pretend you're stroking the shapes of the carrots. Then, still in mid-air, pretend you're stroking the roundness of the carrots. These two actions are in opposition to each other, showing you how to use brush strokes to create dimensional shapes.

Step 3

with touch-ups to backgrounds and foregrounds. If you do repaint these areas, make sure you bump them against the shapes of the subjects carefully. Don't be afraid of letting the colors touch. If you leave a little line of the old application, its tone and hue might be a little bit different. This little bit of difference shows up as a halo around subjects, not only wrecking their shapes but reducing the appearance of dimensionality.

Step 4

The Finished Painting

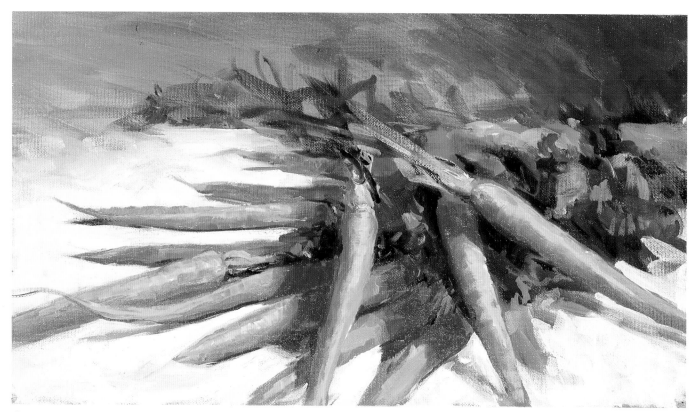

Step 5

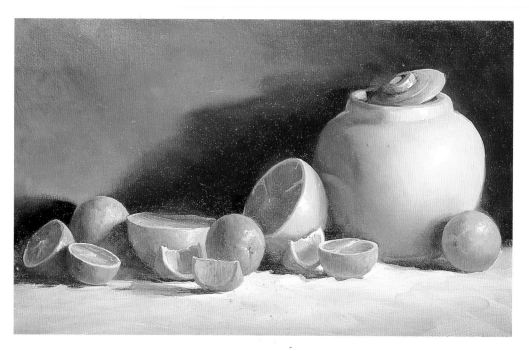

Vitamin C, 12 x 24.
Who knows how an idea generates a painting? It can come from colors, shapes or textures. I like a still life composition to have a theme, extending an idea. Starting with oranges, I thought of grapefruit and a vase that was somewhat the same form as oranges and grapefruit. To inject variety and further description of the fruit, I thought of halving and quartering them. I find my still lifes always name themselves because of their themes.

THE COLOR RED

I singled out red to be featured in its own chapter because red is the most difficult of the three warm colors of the spectrum to paint well. It's a wonderful color to include in a composition; it adds excitement.

The difficulty in painting a red subject is where and when you have to lighten its red color with white. Chances are you expect the mixture to get lighter and brighter only to find that it only gets lighter but not brighter. How disappointing, particularly when your subject's red color looks so bright and light. These light, bright versions of red have to be interpreted rather than literally stated by using a mixture of red plus a bright orange and white instead of resorting to only red plus white.

The problem of painting with red is that most red paints can't withstand the addition of white without becoming dull and, often, a bit violety. Many years ago, there was only one permanent red available that could be lightened with an amount of white and show up light and bright looking. That color was Chinese Vermilion, extremely expensive then, prohibitively priced today. But now, there is a less expensive red paint that can take the place of Chinese Vermilion. It's called Grumbacher Red, which, of course, sounds grossly commercial but, in reality is a splendid, proven red capable of staying true despite great additions of white. Its red hue doesn't change in admixture with white; its intensity seems to withstand white's lightening power.

Cadmium Reds have been around for a long time. The only one that I use and recommend to students is Cadmium Red Light. While Cadmium Red Medium squeezed from the tube may *look* like the bright, vibrant red you're seeking, any addition of white turns it into an unexpected, unwanted, dull, dense violet. In Cadmium Red Deep, this condition is even more prevalent.

There are many instances in painting when red should be handled with caution. One of them is red's inclination to bleed into another color, and when it does, it *wounds* the picture's effect (that pun *was* intended). In the case of red lips, don't include the coloration until the very end of the portrait's development. Many little tonal changes have to be made in the area around the mouth, especially the corners, to zero in on an expression. The red coloring could be troublesome, and it is easy to sneak the redness of lips on an already structured mouth.

Red is a strong color, and when it is seen incorporated as part of a subject's coloration, such as in peaches and apples, to name a few, it is the color that should be applied last.

The Weaker Color First

Apples give me a chance to teach another factor of color in action, that of application according to color.

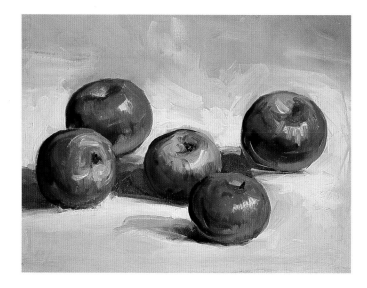

▲ *The shape of the apple in the middle of the basket.*

Blend instead of bleed by shaping light tones with dark ones, weak colors with strong ones.

◄ *The weaker, lighter green color painted in a large area.*

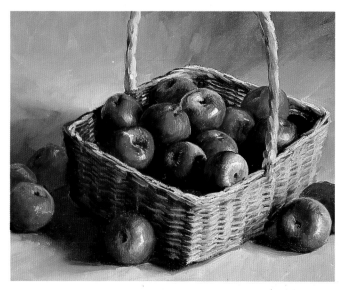

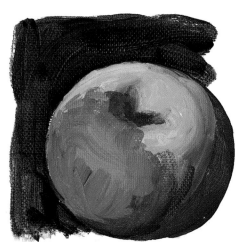

▲ *The stronger, darker red color was used to cut the green down.*

Recognizing Red's Range

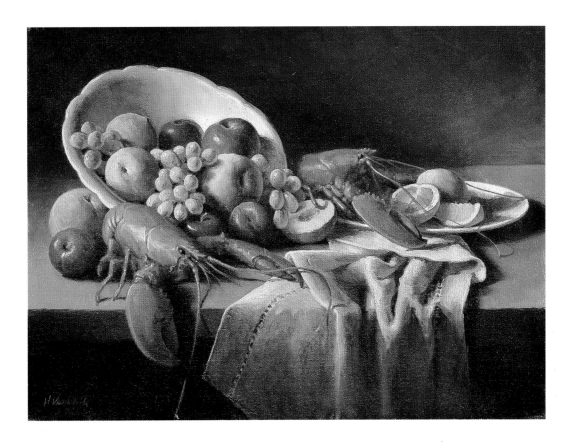

Lightest red: Cadmium Red Light (orangey) *with white*

Red red: Grumbacher Red *with Cadmium Red Light*

Violet red: Alizarin Crimson *with Grumbacher Red*

Darkest red: Burnt Umber and Alizarin Crimson (violetish) *with pure Alizarin Crimson*

Organizing Efficient Painting Time

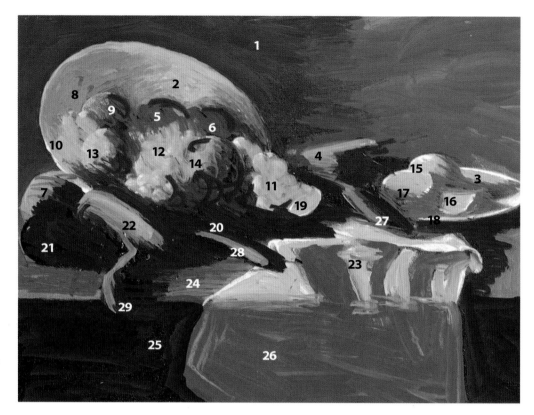

The numbers on the painting represent my progression of application from the first stroke (#1, background) to #26, the drape in the foreground. The numbers in the text give you an idea of the time I spent on the entire project, from inception to the finished painting touches on the cloth.

I'm asked by artists and laymen alike: "Do you paint every day?" An artist's life is not a nine-to-five job. I paint when I'm inspired. When that happens to me, which seems to be quite often, I arrange to have no interruptions. My interpretation of my inspiration is dictated by the time I allot myself or the time I happen to have. If I'm inspired by a bouquet of flowers and I know that I have only a morning free to paint, I wouldn't be able to do them with the precision and care I used for the lobsters. That kind of interpretation of a subject is well planned rather that spontaneous.

I do an underpainting when a subject imposes an additional measure to the ever-present pressure of time. The lobsters in the still life weren't going to wait forever to be eaten and the cut lemon and peach wouldn't look fresh for days either. Doing an underpainting does not make the painting process take longer, instead it makes it easier, more efficient and less time consuming. A tonal preparation serves to set down the placement, composition and drawing as well as serve as a beneficial base for color.

The other most-asked question is: "How long did it take you to do this painting?" My answer: "A lifetime," always gets a smile of understanding but it's not the one that satisfies their curiosity. Here then, is the time of each stage of development for the painting of the lobster:

1. **The day before.** Getting the inspiration and cooking the lobsters.
2. **7:30 to 8:30 a.m.** Setting up the still life and lighting.
3. **8:30 to 9:00 a.m.** Placing and proportioning the arrangement on my 14 x 18 canvas.
4. **9:00 to 9:45 a.m.** Doing the underpainting.
5. **9:45 to 10:00 a.m.** Coffee time and drying time for the underpainting.
6. **10:00 to 10:30 a.m.** Glazing of the background, bowl, fruit, lobsters, tablecloth.
7. **10:30 a.m. to 3:00 p.m.** Painting on each subject with light and dark mixtures on top of the wet glazes. Because the glazes are not thick but not running either, they are a joy to work on. They help me ease additions of color onto the canvas and serve as blenders for them. I've numbered the progression of applications on the underpainting.
8. **3:00 to 4:30 p.m.** Light and dark accents.
9. **The next day. 8:00 a.m. to noon.** The highlights on the fruit and the lobsters. Reflections in the shadows of the fruit. Detailing the lobster's feelers and legs. The detail of the hem of the cloth.

Few people work at the exact same pace. We have to recognize how our work clock is paced. My pace seems to be a fast one. When you set up time to paint, take your own particular pace into consideration.

CADMIUM RED LIGHT

Cadmium Red Light is a bright orangey red. It's an excellent red to use with Yellow Ochre and white for basic flesh colors. Darken and redden Cadmium Red Light with additions of Alizarin Crimson. Even though the cadmium colors are considered opaque, you can glaze with them. They do have to be thinned with a medium to make them a glaze but never make them runny. All the cadmium colors are expensive but strong, which means you don't have to squeeze out much. Another factor that eases their high cost is that they dry very slowly and will remain workable on your palette for days or even weeks. There are more cadmium reds available: Cadmium Red Medium and Cadmium Red Deep. Both are quite useless because they dull down drastically when mixed with even a touch of white.

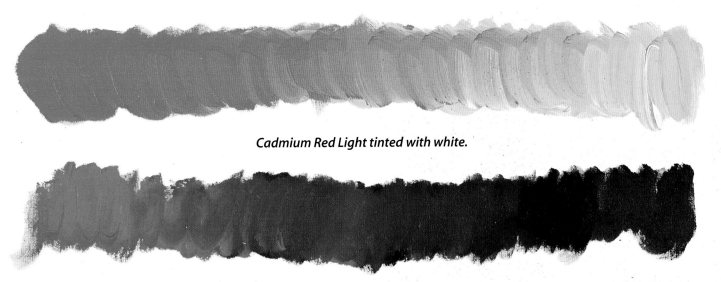

Cadmium Red Light tinted with white.

Cadmium Red Light darkened and grayed with Thalo Green and Cadmium Yellow Light.

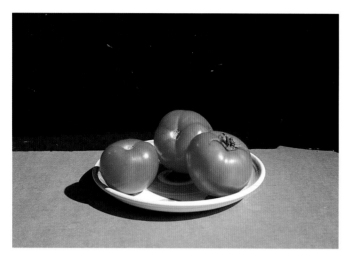

Figure 1

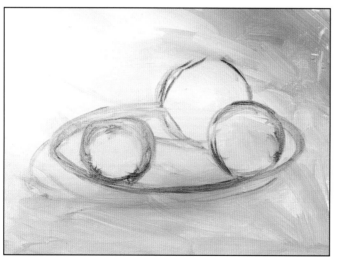

Step 1

There are many cadmium colors. All are valuable except Cadmium Red Medium and Cadmium Red Deep.

FIGURE 1. Since the color red is a medium tone, its color and value have to be seen against a dark background or a light one. The white plate serves as the necessary light contrast and the dark background contrasts the lighter tones of red caused by the lighting from the right. Always paint colors in advantageous conditions.

STEP 1. You can see by comparing my drawing to the actual setup (Figure 1) that I decided to make some changes. Try to seek out interesting shapes. The actual arrangement looks crowded and the tomato on the left was in danger of just touching the large tomato. That's a kiss! That's a no-no!

STEP 2. Before working on the tomatoes, I painted the background and the back part of the plate. Of course, I started with the large tomato before doing the one in front of it.

STEP 3. I corrected the bottoms of the tomatoes with their cast shadows of dark violet, complementary to the plate's yellowish color. The plate's bottom was corrected with its cast shadow on the table, made of Alizarin Crimson and black, a dark violet complement of the table color which was made of black and white, Yellow Ochre and Burnt Sienna. I redid all the tomatoes' highlights with white and a touch of Thalo Green (almost white) I usually paint the highlight bigger than it is and cut it down with the lightest body tone. Make sure the shape of the so-called outline coincides with the tomatoes' inner anatomy, which is most obviously seen by their highlights.

STEP 4. The finished painting (page 42). The subject's so-called outlines were better defined by first lightening the white plate and moving the tomatoes' red color out into the plate tone. The cast shadow was darkened to somewhat match the shadow tones of the red tomatoes. This served to unify the composition and set the tomatoes' little fannies firmly on the plate. It's important to realize that all the tones you paint must serve to present a subject convincingly and artistically. While you worry about the colors of things, your canvas is worrying about how the tones of your colors are affecting the composition.

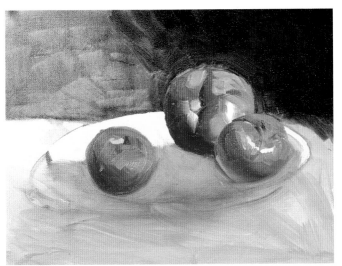

Step 2

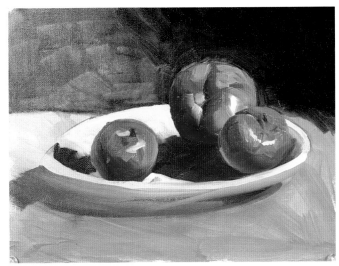

Step 3

This diagram shows how the red body tone gets more intense and darker as it rolls toward the shadow. These are the mixtures starting at the light body tone of Cadmium Red Light and white. More Cadmium Red Light was added to diminish the white in the mixture and Grumbacher Red was added to that. Some Alizarin Crimson and Thalo Green were added to the last mixture to shadow the tomato color. All colors, not only tomato color, get darker and more intense just before they roll into shadow.

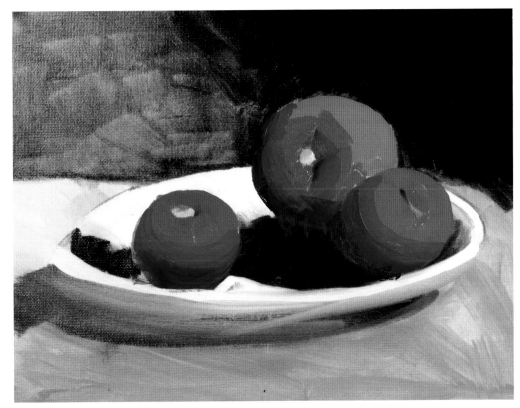

Diagram

The Finished Painting

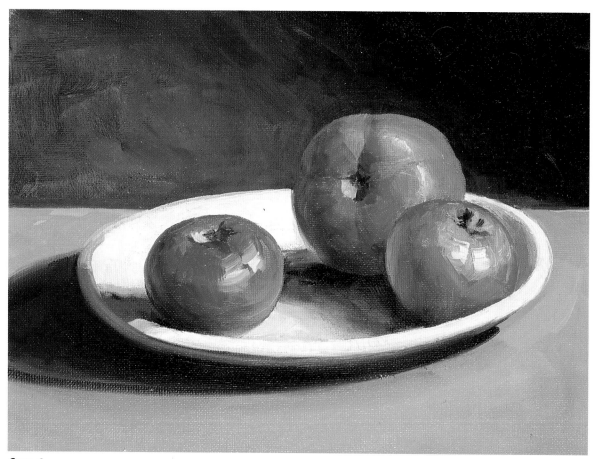

Step 4

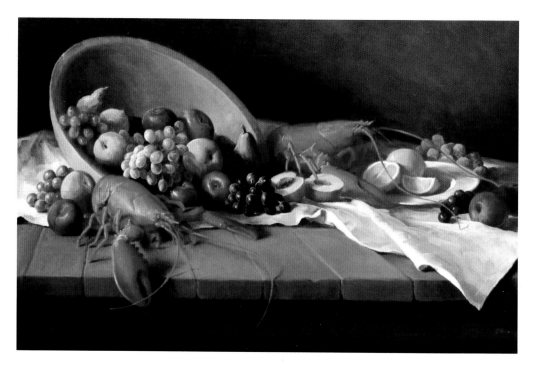

New England Theme, 20 x 24.
You can see very clearly how
all the colored objects in this
painting are shadowed on
the right. Notice how each
object's color darkens and is
more intense just before it
falls into shadow. Cadmium
Red Light is a necessity
when painting this delicious
crustacean.

GRUMBACHER RED

Grumbacher Red is in the family of reds that I call "neutral" red. Other manufacturers have this very same red and they, too, have given it a proprietary label: Winsor Red, Shiva Red, Weber's Bright Red, are a few. I have used all of them and find hardly any difference among them. Since I have had more experience with Grumbacher colors than with other oil paint brands, I am more familiar with Grumbacher Red and use it as the neutral red on my palette. The description and characteristics of Grumbacher Red, which I am going to enumerate for you, will also apply to all the other reds in the neutral red classification. Grumbacher Red is a bright, medium tone with no hue tendency which becomes obvious when white is added to it. Grumbacher Red neither veers toward orange nor blue, as other reds do. The tint-out also shows how well it maintains its brilliance. It's a wonderfully useful color, a really true American-flag red.

Back in the early 1950's, before any manufacturer had this color in its line, the one red that was closest to it was Chinese Vermilion Red, then priced at $9.00 a tube, and it wasn't as potent as the neutral reds of today. Before it was available, in order for me to get something that approximated it (who could afford to spend $9.00?), I mixed Cadmium Red Light and Alizarin Crimson together, but it was tricky. If I lightened the mixture just a bit the violetness of Alizarin Crimson managed to dull my mixture. We really have more colors available to us today than in the days of the old masters. We can't get the wonderful results they got because we don't interpret our observations as well as they did. They never saw the look of nature through the lens of a camera. They only saw the work naturally illuminated and thus painted it so. Our vision of things in nature is so often a remembrance of how they look in a flash snapshot which makes everything look flat.

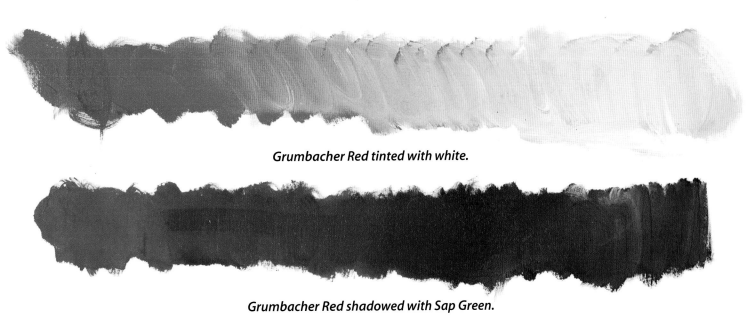

Grumbacher Red tinted with white.

Grumbacher Red shadowed with Sap Green.

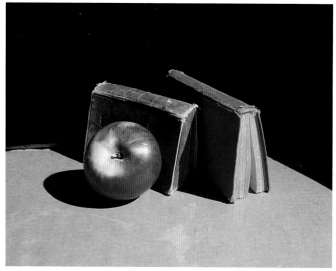

Figure 1

FIGURE 1. The setup

STEP 1. I roughly suggested the shapes of the books and the apples, respecting the size of my canvas. If you are careful about the placement and size of your composition, the viewer will accept these sizes. Yes, it was a rather big apple and the books are old, little text

books. I thought in combination I could recollect my teen-age evenings of doing my homework. Try to inject some sense into still life arrangements. I could have also added some pencils to the composition, to further reminisce about high school days, but my primary reason to do the painting was to write this chapter to acquaint you with Grumbacher Red.

STEP 2. My tonal evaluation in black and white acrylic clarified the shapes of the books and apple. After the underpainting was fully dry (about ten minutes) I did the background with oil color. Starting at the left of the canvas, I massed in a mix-

ture of black and white and Burnt Umber. Then I added more Burnt Umber and some Burnt Sienna into my mixture to intensify the color. I shadowed that mixture with a touch of Thalo Blue and Alizarin Crimson, ending up with the darkest value of the background in the right hand corner by adding Burnt Umber into the previous mixture. When painting in a gradation of a color for a background, always start with the light tone and darken that entire amount left on your palette by adding more color and tone into it. To paint in an even darker tone, turn that entire mixture into the next tone and color. A gradation from light to dark makes a background interesting but it's not as easy as it seems, especially if you think backgrounds are not worthy of your effort and artistic attention.

STEP 3. With the background done, I did the red book, lightening my Grumbacher Red with white and Cadmium Red Light. I darkened that color by adding more Grumbacher Red, some Alizarin Crimson and just a bit of Thalo Green. These shadows are on planes that are greatly effected by reflected light and do not have to be grayed that much by a complement. I found it necessary to interpret the red color of the apple

Step 1

(Grumbacher Red and a bit of white), lighter in contrast to the blue book's shadow side: white, some black, blue and Burnt Umber. You can always accentuate a body tone lighter and a shadow darker if you think it will improve the presentation and dimension of your subjects. Because yellow green can be more easily overtaken by darker, more potent red, I massed the yellow area of the apple in larger than it was and cut into that application with Grumbacher Red. Of course, I shadowed the red with green (I used Sap Green instead of Thalo Green). It was more compatible to the yellow green area.

STEP 4. The finished painting (page 46). I added dark red into the shadows: Alizarin Crimson and Grumbacher Red and lightened the body tone with white, Grumbacher Red and Cadmium Red Light which improved its contrast to the dark book. I "finalized" the apple with its highlight of white and a touch of Thalo Green. Some professional advice: It's easier to paint a bunch of apples than just one. The one you do paint will always be scrutinized very carefully whereas a bunch is accepted as just that—a bunch. If one of the apples is painted rather convincingly, the rest become guilty (or glorified) by association.

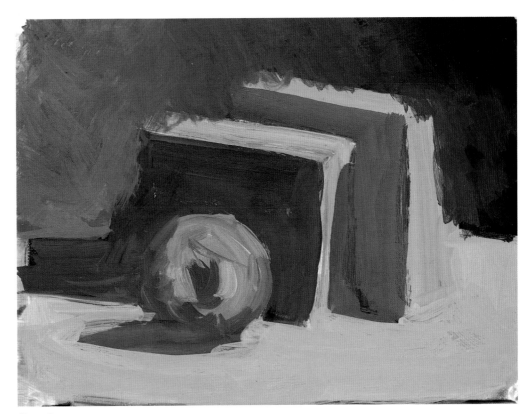

Step 2

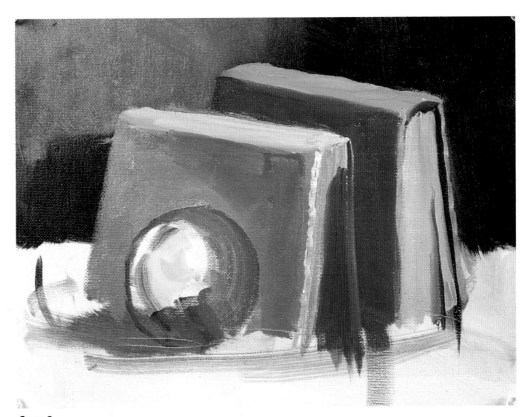

Step 3

The Finished Painting

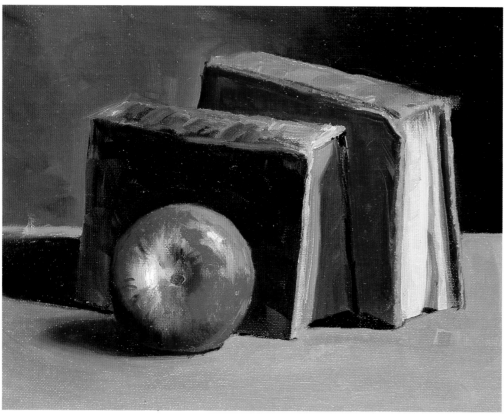

Step 4

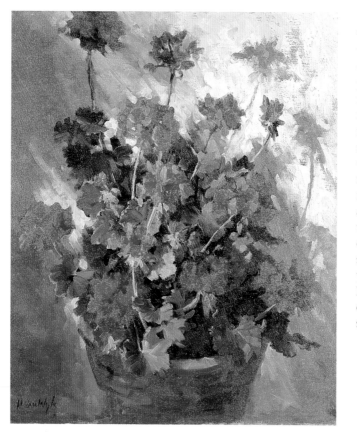

Geraniums, 20 x 24.
This is only one red flower that justifies having a Grumbacher Red on your palette. Petunias are red; roses are red; carnations are red. All these red flowers need lighter tones of red to show their dimension. Grumbacher Red and other neutral reds are the only reds that can withstand amounts of white added to them and still remain a red color. You'll have more success with red flowers if you do not thin the paint. Painting is more a matter of piling the paint on than stroking and blending.

8

YELLOW OCHRE

Yellow Ochre is an earth color that I find indispensable. Its medium light tone and neutral intensity is prevalent in nature: beach sand, trees, bushes in winter, rocks and marsh grass. Lots of somewhat colorless surfaces such as cement walls that are in light cry out for the use of Yellow Ochre. Mixed with any of the reds (Venetian Red, Cadmium Red Light, even Alizarin Crimson) and white will give you a flesh tone possibility. Try using Yellow Ochre with a touch of Thalo Green plus tones of black and white for muted background colors. Yellow Ochre is a good choice to warm an off-white mixture for white vases. This, and all the other earth colors, has been reliable and has been around for years; I find it essential on my palette.

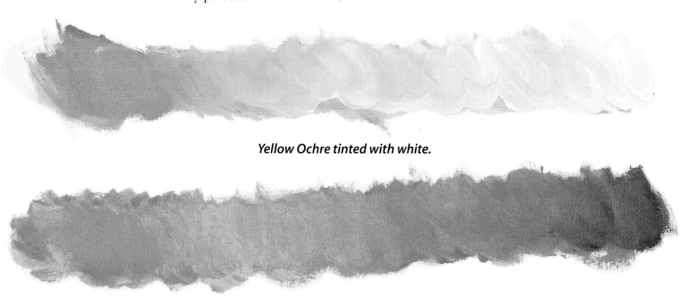

Yellow Ochre tinted with white.

Yellow Ochre darkened and grayed with Alizarin Crimson, black and white.

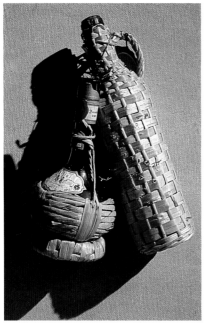

Figure 1

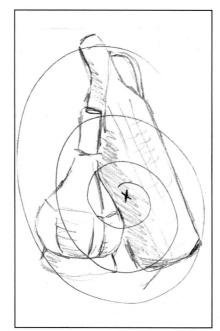

Figure 2

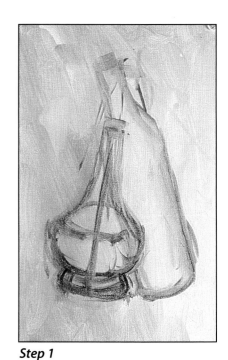

Step 1

FIGURE 1. This arrangement is an example of *trompe l'oeil* (French for deception of the eye, pronounced trump loi). When a subject has no foreground, it seems to look like it is on the canvas surface. It's a fascinating type of painting to try and these types of pictures are greatly admired. People usually comment, "I can pick that bottle right off the wall." Other ideas of a similar nature: a dust pan and brush, a garden pail, a violin or other musical instrument with some music stuck behind it, an interesting hat, or an old hat and scarf. Just think of how many things you can hang from a hook.

FIGURE 2. These two bottles look like they enjoy being together. The focal point area starts at the lower right third. All paintings should have a starting place of interest that then spreads out to justify the entire arrangement. This instruction is necessarily repetitious in each chapter because a focal point is an absolute requirement of a successful painting. The X marks the

start of your viewing experience; it draws your attention that then enjoys the rest of the painting. The focal point is often referred to as the center of interest.

STEP 1. Might as well start with drawing the shapes of the bottles and their size relationship to each other and to the canvas.

STEP 2. Mass in the basic colors. The light areas of the bottles (white and Yellow Ochre) with a touch of Burnt Umber. Add some black and Alizarin Crimson and some more Yellow Ochre to suggest the shaded areas.

STEP 3. The wicker on the tall bottle has been painted. Diagrams A and B show you how to do it. To paint the wicker bottles, you must first paint in their basic shapes that simply look round. Then add the effects of wicker by first indicating the stays of the wicker with thinned Burnt Umber (Diagram A). Then add the

All paintings should have a starting place of interest that then spreads out to justify the entire arrangement.

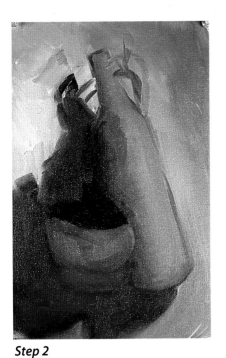

Step 2

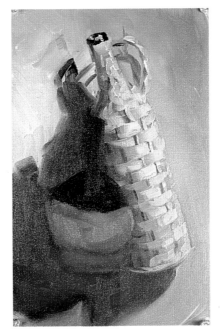

Step 3

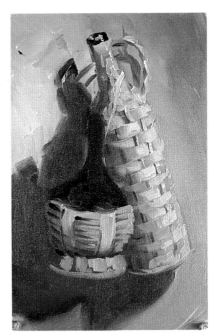

Step 4

wicker effect with strokes of a lighter mixture across the stays. Don't try to do wicker by going around the bottle. Instead, add the weave to each stave, starting with the one that faces you, and alternate the wicker on the next stay (Diagram B). Notice how perspective makes the stays get close together as they round the bottle. "Wickerize" the light side of the bottle first and then suggest it on the shadow side with darker tones.

Use Yellow Ochre and some Cadmium Yellow Light into white to add the weaving. Use a darker version of this (less white) to suggest the weave in shadow. Accent the weave with dark accents of Burnt Umber that has been greatly thinned so it flows off your small painted brush.

STEP 4. The smaller bottle needs the same treatment.

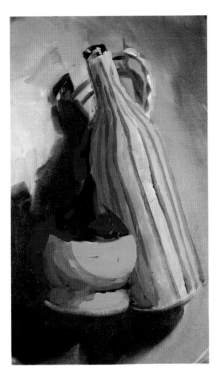

Diagram A

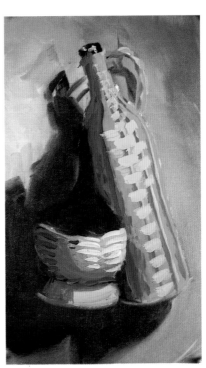

Diagram B

The Finished Painting

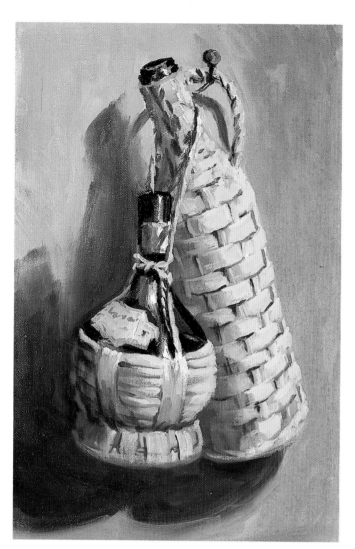

STEP 5. The finished painting. The background acts like a broom that puts your job in order. Backgrounds are always part of the beginning laying in of paint. It is so often used to correct the subject's outer shape not to mention the shaping in of the cast shadow. The final addition to the background is to lighten it on the left side of the subjects. By doing so, you show how the lighting came from the right, then struck the bottles that cast the shadows, and finally lit that area of the room or wall.

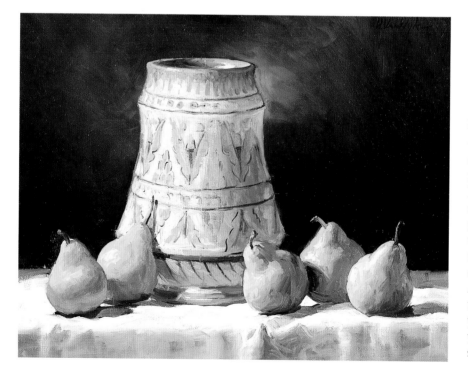

Tuscan Pottery and Pears, 16 x 20. It's important to understand as well as to see your subjects. A good way for me is to feel my subjects' shapes with my hands while my eyes are closed. Doing this helps me guide my brushwork. The Tuscan vase was chunky in character with five shapes. The top shape was small, stopping at the next shape which was fuller and rounder. This was followed by brushwork that would form the larger part of the vase which got wider as it sloped. I painted the five parts of the vase's shape, connecting them instead of drawing an outline. Notice the sensibility of the pears' anatomy. A pear is basically a combination of two forms: the upper part of the pear sits on the larger, round shape. Analyze the structure of things so you can direct your brushwork to describe your understanding of the subject's structure.

RAW SIENNA

Raw Sienna, another earth color, was originally found near Siena in Tuscany, hence its name. It is a yellow orange of medium intensity and useful in admixture with other warm colors to record the many versions of medium-toned yellow orange that we see in nature. Raw Sienna makes a dull yellow green when mixed with Thalo Green. It adds warm color into the interior of the shadows on lemons and other light yellow colored things. Its color from the tube can be used for the mass tone of gold. You may think that the color is too dark for gold, but remember, the all-important mass tone is never the lightest color you see on an object. Save the tone for the highlights.

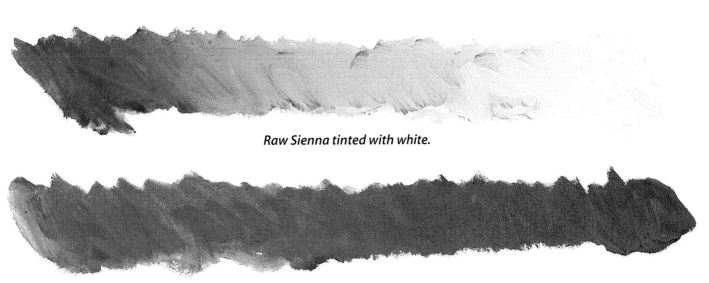

Raw Sienna tinted with white.

Raw Sienna darkened and grayed with Alizarin Crimson, Thalo Blue, black and white.

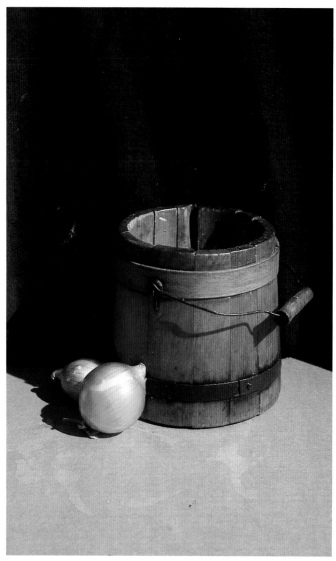

Figure 1

FIGURE 1. I don't know what this bucket was originally used for but I store onions in it, which made painting it with onions seem like a natural.

STEP 1. The placement and some drawing gets you started.

STEP 2. When painting a subject against a dark background you must mass in a background before starting on the subject. You may go back and repaint it to improve it but never drastically change its tone. After roughing in the basic light and dark and the foreground, paint the bucket, using the following progression of application:

1. The mass tone (or body tone): Raw Sienna, Burnt Sienna and white.

2. The mass tone slightly darkened and intensified: add more color to reduce the amount of white in the mixture.

3. The shadow edge is blue violet (complement of yellow orange): Thalo Blue and Alizarin Crimson into #2 mixture.

4. Then the actual color, only darker, appears in the shadow because of general illumination: Burnt Sienna and Burnt Umber mixed into the #3 mixture.

Step 1

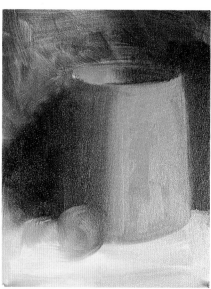

Step 2

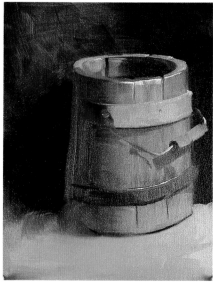

Step 3

5. The reflected light, in this case a lightened #4 mixture. The reflected light color depends on what is causing the reflection.

This procedure is a basic one to paint in the tones and colors of any color seen in light and shade caused by one source of light. To repeat:

1. The color
2. The color darker
3. The complement
4. The color in the shadow
5. The conditional reflection which, by the way, can't be as light as the body tone.

Diagram A shows the paint application in across strokes which make up-and-down blending strokes with a clean, damp brush more effective and often successful. Another example of painting with opposite strokes.

STEP 3. You can see from this rough example of the finished picture that the slats were indicated with some dark lines and the cool gray highlight of gray and blue was added too. The band of light yellow wood was added using up-and-down strokes of light versions of the 1, 2, 3 and 4 color mixtures on Step 2. The metal ring was added, using black, some white and Burnt Umber.

DIAGRAM B. The onions were done with pretty much the same mixture used to paint the bucket. The brush applications were started in across strokes and then blended with strokes suggested by the characteristic onion skin.

STEP 4. The finished picture (page 54). You can see that I made some corrections of shapes and refined the edge of the shapes. This had to be done to compensate for the speed in which I did this painting on my *Welcome To My Studio* television show. Under normal painting conditions, I take the time to correct as I go along, leaving the adding of only some lighter and darker accents to finalize the painting.

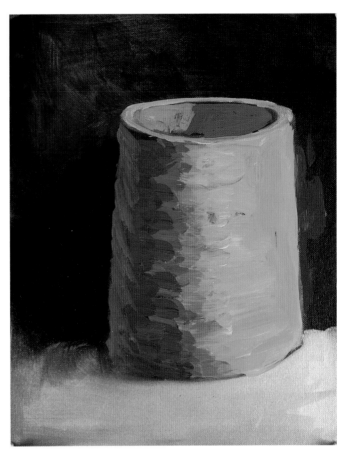

Diagram A

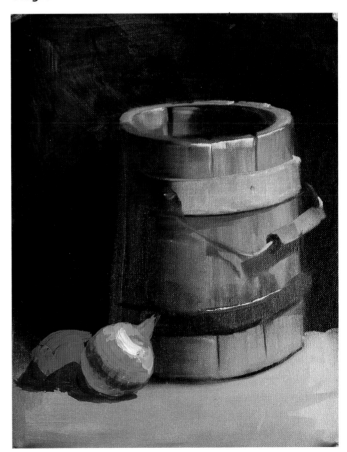

Diagram B

The Finished Painting

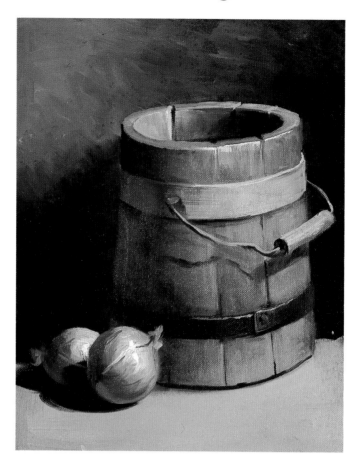

Step 4

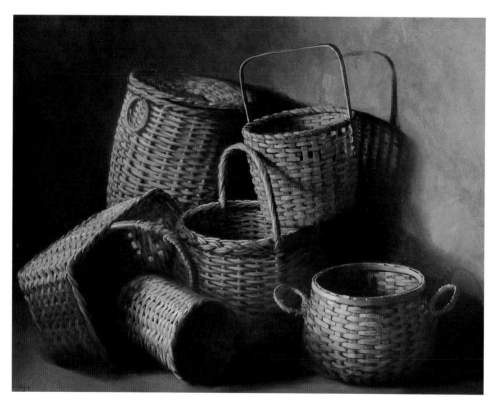

A-Tisket A-Tasket, 30 x 40.
A cylinder is one of the five basic shapes and seen in perspective, its roundness becomes an ellipse, not the easiest shape to draw. An ellipse is not an oval. This 30 x 40 painting was big enough to show how perspective affected the ellipses. The lower basket on the right has a more open ellipse than the tilted tall basket on the upper left. You can see by this picture that I've had enough practice to tell you how to do wicker.

LIGHT RED

Light Red is an oxide color, not to be confused with the cadmium color, Cadmium Red Light. Light Red, also called English Red Light, is a chromatically reduced red that's very much like Venetian Red, Terra Rosa, and Red Oxide. Light Red will add some opacity and will redden Alizarin Crimson. As an ingredient in a basic flesh mixture along with white, any yellow or orange, Light Red is a wonder. The pink coloration of Light Red when mixed with white is extremely useful in painting flowers. You will find you won't need much of this color, and you won't use it that often, but your palette of various reds wouldn't be complete without it. Don't squeeze out much; a little goes a long way.

Light Red tinted with white.

Light Red darkened and grayed with Alizarin Crimson, Thalo Blue, black and white.

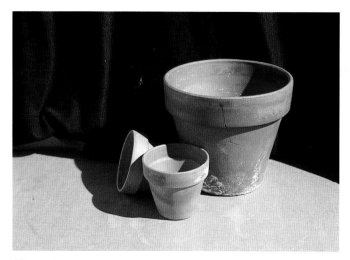

Figure 1

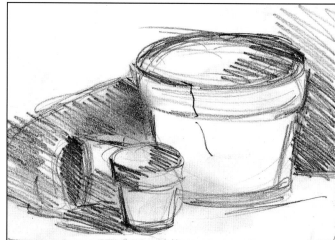

FIGURE 1. A clay pot is an excellent example for the use of Light Red. It's also a good subject to study the mechanics of light and shade because its texture is so matte; it is not at all shiny. This means that you have to create dimensions without the benefit of highlights, and reflections too, for that matter. In order to record clay pots, you have to abide by the basic color principles.

1. The body tone is the color of the illuminated area, Light Red, Yellow Ochre and white.

2. As the color nears the shadow, it has to be intensified by adding more Yellow Ochre and Light Red to the body tone mixture. This mixture eases the body tone towards the shadow. Look at all the photos of the subjects in this book and, especially, look at the color next to the shadows.

3. Where that clay color falls completely in shadow, add some Thalo Blue into the intensified body tone mixture.

4. Once you have blended that shadow color, you'll see the clay pots' color look like it's turning into shadow. That's why it's called the "turning point." It's an area that needs careful attention and, I must admit, a lot of work. Often, the blending that is necessary doesn't record the right shape. Besides, it has to be done by easing the color's complement into the object's color.

It's a good idea to do a thumbnail sketch of your still life before tackling your canvas. Here's an example of what a thumbnail sketch should contain: the subject's placement, the subject's drawing and an indication of the lighting.

5. Into that shadowed color, add some Light Red and some Burnt Umber to record the color of the inside of the shadow.

6. By comparing the finished painting on page 58 with the actual subject, you'll see a grayness that seems to skim over the body tone. Even though I've said that you don't have the advantage of painting a highlight, you do have to impart a grayed color to suggest the feeling of light. Add more white into the basic red tone and a breath of Burnt Umber. The resulting mixture will be a relatively cooler, reddish mixture that's so suitable to add the kind of gray haze to the light area of the pots.

Diagrams A and B suggest how to do the crack in the pot. Using a small round brush, sketch in the crack with greatly thinned Burnt Umber (A). Then add the light body tone on the left side of the crack (B). Don't overdo it.

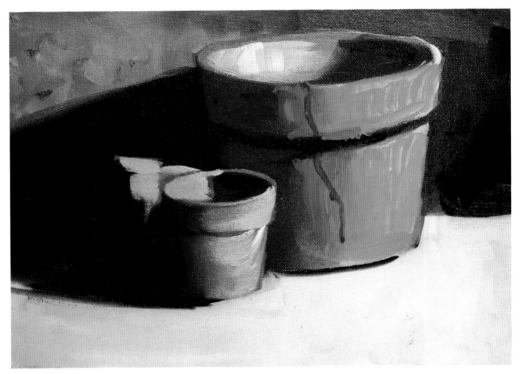

Diagram A

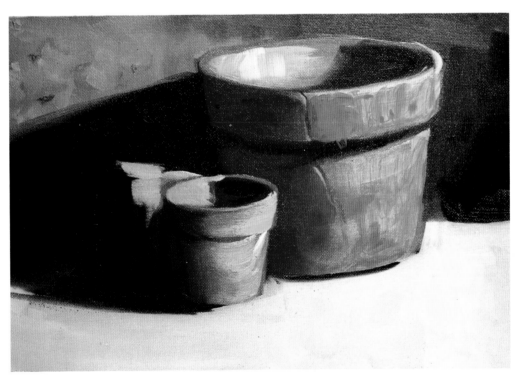

Diagram B

The Finished Painting

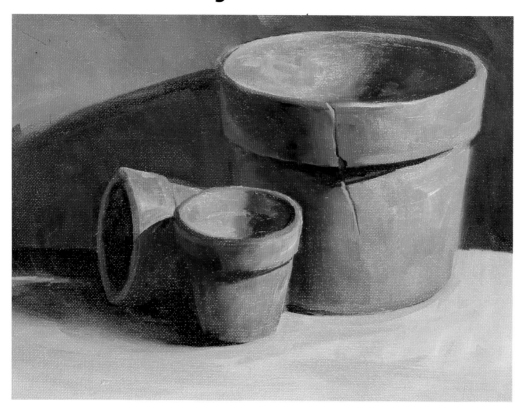

Don't Confuse Light Red for Cadmium Red Light

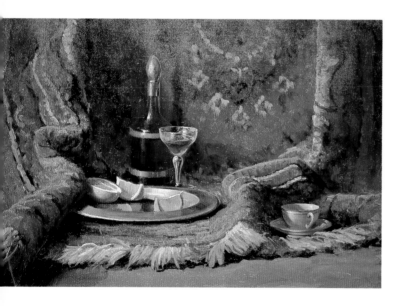

These two paintings — (right) *Old Books, 16 x 20,* (above), *Dutch Tablecloth, 20 x 30* — show the use of Light Red. Old books are often a dull red color, so easily made with Light Red. This color also made Alizarin Crimson opaque and more red to depict the color that's so typical of the heavy Dutch rugs that are used as table coverings.

BURNT UMBER

Many people think Burnt Umber is a brown. In the language of the spectrum there is no such color, for as you know, the spectrum is made up of six colors: yellow, orange, red, violet, blue, green. Of those six, Burnt Umber, when tinted with white, is plainly identified as a kind of yellow, one that is dark and dull. While it's true that nature needs only one version of each primary color, painters need more than one to mix all tones and intensities of a color. Burnt Umber should never be used as a darkening agent for shadows, even though its name is derived from the Latin *umbra*, which means shade. Burnt Umber is a dark version of yellow and can be mixed with white for very light tones too, when a yellow is described as a light, dull yellow, such as sand or the color of an old, yellowed letter.

Burnt Umber tinted with white.

Burnt Umber and Thalo Blue lightened with more white.

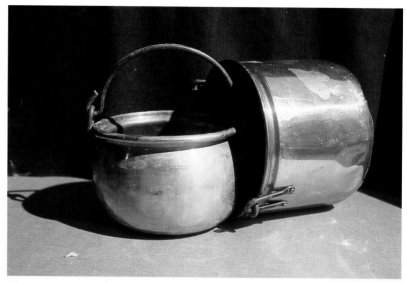

Figure 1

FIGURE 1. Brass is a good texture to sing the praises of Burnt Umber. Yes, brass is bright yellow but it is not the color of a lemon, which is an example of bright yellow. Maybe the highlight is bright and light but the general tonality of brass is a darkened bright yellow. The brightness of brass requires bright Cadmium Yellow Light to be used but brass's dark tone requires the addition of Burnt Umber, a dark yellow.

STEP 1. The placement and composition.

STEP 2. The basic lights and darks could be washed in with turpentine, black and a little white for the darks and a thinned light gray for the light areas. I did this step with watered-down black and white acrylic paint. I'm a great fan of starting a painting with what is called an underpainting. Dark colors look better painted on dark tones, light colors enjoy being painted on light tones. It is also a way to concentrate on composition, drawing and tone without the complication of thinking about color, too.

STEP 3. After painting in a dark background color (black and Venetian Red, with maybe some Burnt Umber), use the following procedure: Paint in the brass pot on the right (if you are right-handed, you may feel more comfortable starting with the pot on the left). Paint the highlight. Always paint any metal by starting with its highlight. To add such a light, bright highlight onto a painted-in mass tone, would dirty the highlight color. Make it out of white and Cadmium Yellow Light. Make it wider than you see it. Then add more Cadmium Yellow Light, a touch of Cadmium

Orange to the mixture and cut the highlight down.

STEP 4. Once the highlight area is painted very brightly, paint in the general brass color on the rest of the pots, using Cadmium Yellow Light mixed with Burnt Umber. These mixtures can be blended in with a large, soft brush. The highlight area can be cut down with the basic mixture of Burnt Umber and Cadmium Yellow Light. Into the basic-toned areas you see shadows. Paint them by adding a touch of blue and Alizarin Crimson to the basic mixture. Use the same procedure to do the other pot. After painting in the dark cast shadows on the pots and table with Thalo Blue, black and Alizarin Crimson, paint in the table color (black, white, Burnt Umber and Burnt Sienna).

STEP 5. Put some Raw Sienna and Cadmium Orange into the shadow color to add the table's reflections into the lower areas of the pots. With a clean damp brush correct the shapes and blend in areas that look too roughly painted.

STEP 6. The finished painting (page 62). Use a lighter tone of white and Cadmium Yellow Light to accent the highlights. I know many students want a smooth blended effect; so do I at times. Always paint in tones and colors broadly and as accurately as possible with enough paint to cover the area with no thought of smoothing or blending. Then, with a soft, clean brush, dust the colors together (a Hake brush is ideal for this, or a very large soft filbert type bristle brush). After dusting, or smoothing, accent and redefine the light and dark tones and colors.

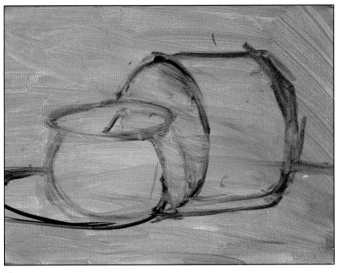

Step 1

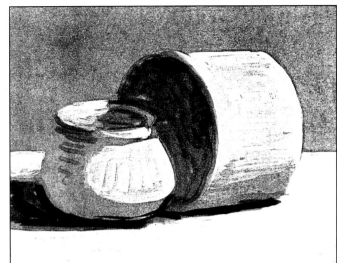

Step 2

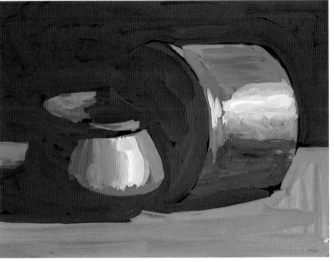

Step 3

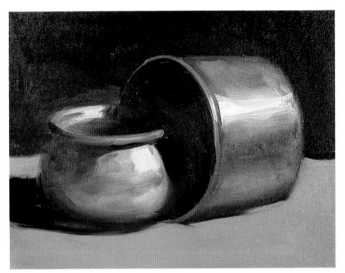

Step 4

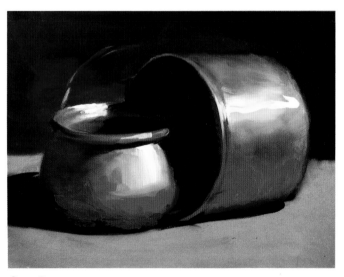

Step 5

The Finished Painting

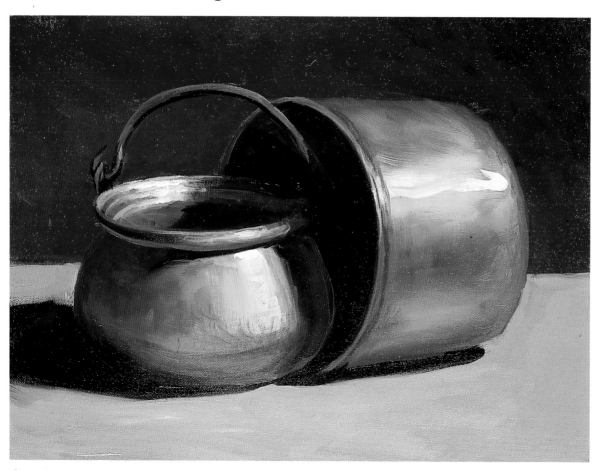

Step 6

Hand-woven Shawl, 20 x 30. Here is another example of the use of Burnt Umber, so different from its use with Cadmium Yellow Light to make brass. In this case, Burnt Umber was mixed with white to get the beige color of the shawl. It was mixed with Burnt Sienna and black and white to make the brown table color. Burnt Umber was also incorporated in the green-colored background. Burnt Umber is a valuable color. It's the lowest intensity yellow. Again, I want to caution you to never, ever, think of Burnt Umber as "shadow color" and use it to darken any old color into shadow.

BURNT SIENNA

Burnt Sienna, still another earth color, is a joy to have on your palette. Because it is a true dark orange with no hidden hue tendencies, it can do no wrong in admixture with any of the warm colors of yellow, orange and red. Its transparency makes it very suitable to use as a glaze as well as making clean tints. Of course, when mixed with a cool color such as green, a nice warm murky green appears and lighter versions of that green can be made by adding degrees of white. Mixed with blue (its complement) black and white, it makes lovely grays — warm if the Burnt Sienna predominates, cool if the blue does. Burnt Sienna seems to cancel out the violet in Alizarin Crimson and adds to it a nice warm glow. It's really a dark orange and with Raw Sienna and Cadmium Orange it completes a wide range of orange's tones and intensities.

Burnt Sienna's origin is Raw Sienna. The Raw Sienna pigment is calcined (roasted at high temperatures) to give us this extremely beautiful and versatile burnt version. The same process converts Raw Umber into Burnt Umber. The heat in both cases darkens and warms the pigments.

Burnt Sienna tinted with white.

Burnt Sienna, black and white darkened with Thalo Blue.

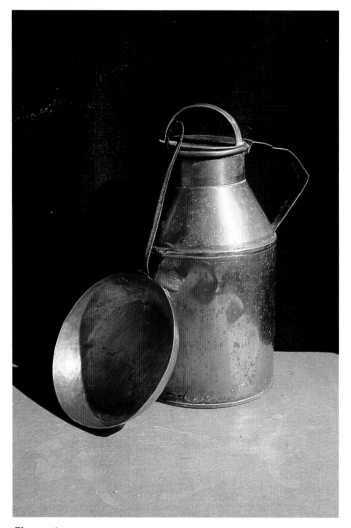

Figure 1

FIGURE 1. I arranged two copper objects to show how to use this dark orange. Again, the light streams in from the right, making dramatic contrasts.

STEP 1. I never mind the funny look at this stage. The rough drawing just serves to show me how the subject fits the canvas and gives me an indication of the basic proportion of the objects.

STEPS 2 & 3. I painted in a dark green background (Thalo Green and Burnt Sienna into black and white). The black and white addition to colors gives the mixture body and "coverability." With a corresponding background color done, I could judge and mix the light tone of the copper color. I roughed in a highlight color of white, Cadmium Orange and Cadmium Red Light. Between the background and the copper highlight I could determine the tone of the copper, deciding on white, a bit of black and Burnt Sienna.

STEP 4. I added even a lighter mixture of white, Cadmium Orange and Cadmium Red Light to the highlight areas and a shadow made of Burnt Sienna and a bit of Thalo Blue.

STEP 5. You can see that all types of handles were added on after the basic shapes were painted. This is the finished picture that I did on my television show which, as you know, permits me only 26 minutes to paint (and talk). As far as I was concerned, this picture was finished. It was the best I could do with the time allowed. Many students don't realize how determining the time element is on the look of a painting. People who admire a loose, free look of brush work ask how that effect was done. My answer: "I was in a hurry."

STEP 6. The finished painting (page 65). This shows the same painting with a face-lift. I spent some time correcting shapes, often easier to do by enlarging the subject. Notice the difference between this step and Step 5. With dabs of a brighter mixture of white, Cadmium Orange and Cadmium Red Light, I improved the highlight area of both objects. Right here I'd like to point out that some of my paintings shown in this book were face-lifted beyond their appearance as final paintings on my TV series. On TV, in order to quickly cover the canvas, I thinned the background and foreground colors so much that I realized they had to be repainted. Moreover, I couldn't ignore the haphazard shapes that were a result of television expediency. They say a professional is a person who knows when he's finished. In this situation, I felt I wasn't finished until the paintings were suitable for reproduction in this book.

My television show permits me only 26 minutes to paint (and talk).

Step 1

Steps 2 & 3

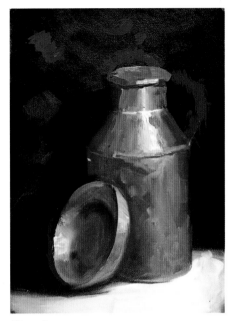
Step 4

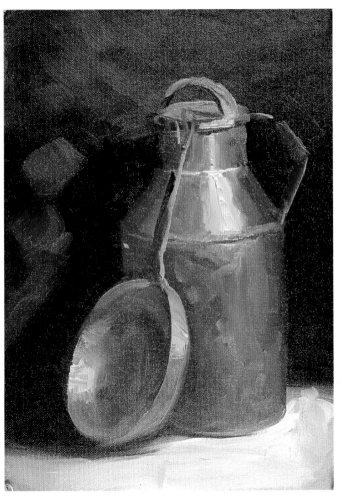
Step 5

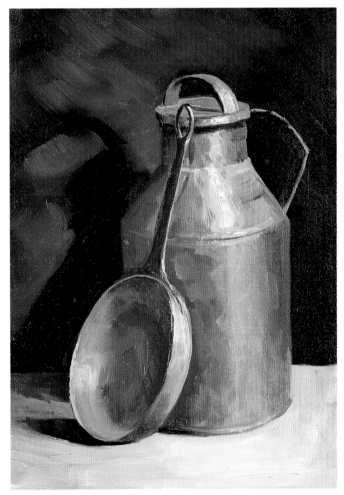

The Finished Painting

Onion Skins, 12 x 16. In this painting, we see two more examples of the use of Burnt Sienna. The pitcher shows it more in its mass tone and the onion in a lighter version of its mass tone. It may seem strange to you that in a book about color I emphasize the truism that textural effects are mainly a matter of dark and light tone and not color. Mastering the use of colors is entirely dependent upon your mastering the five tone values that colors assume: 1) a highlight which is always embedded into 2) a body tone, 3) a reflection which is always embedded into 4) a body shadow, and 5) a cast shadow, the darkest type of shadow. Inspect this painting and see whether you can identify all five tone values.

THE DARKEST COOL COLOR: VIOLET

Much of my instruction about color begins with phrases such as "Artists paint the effect of light," "Make your paint do to the canvas what the light does to your subject" and "Look for the light and the dark." I hope these phrases make you realize that a total understanding of the phenomenon of color will help you interpret the colors you see and will ultimately help you paint better.

Let's study the color violet. For artists, especially landscape painters, violet's importance lies mostly in its role as a complement to yellow. Why? Because *"Artists paint the effect of light."* The light of the outdoors, particularly sunlight, is warm and somewhat yellowish. Violetish coloration, then, can logically represent shade. Since shadowed areas are usually dull versions of violet, they can be quite easily made by mixing most tubed violets into gray.

Quite difficult to interpret, on the other hand, is light shining on violet-colored subjects, principally flowers. Most of the tubed violets are intense only in their medium and dark tones. As soon as amounts of white are mixed into violet paints, their brilliance seems to diminish greatly. Consequently, you must exercise great foresight to avoid the lightening of violet colors with a lot of white. The range of the bright tones of violet is not as extensive as the ones for the other cool colors, blue and green.

How do you overcome this liability? Choose carefully a background tone that will help you to deal with the color violet more successfully. Avoid a middle-toned background; use a very light one, forcing your interpretation of vibrant violet colors to be dark and intense in relation to it. Or make your background very dark, which will stop you from having to mix a lot of white into the violets to make them light.

No discussion of color can be complete without a few cautions that I feel are important. As a painter, do not let preconceived ideas and emotions influence your use of colors. In the case of the color violet, I'm not saying that you must paint violet things even though you don't like the color. I'm saying use violet—and all the other colors, for that matter—as though it is a working part of a painting experience. I too, have my feeling about violet. It has long been considered the color of royalty and, far worse, the color of death. But on the plus side, its value as yellow's complement can't be brushed aside. And, certainly, violet's a flattering color for blondes to wear.

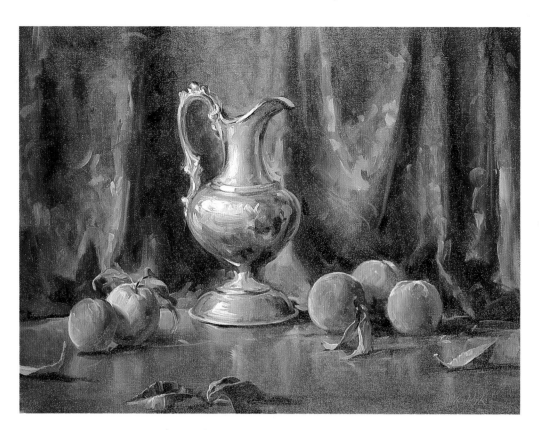

Rare and Royal

I used muted violet hues for backgrounds. Violet is muted and shadowed with its complement, yellow, but, one wonders, how could yellow, the color of lemons, be used for shadowing and toning down a color? Knowing that Raw Umber and Burnt Umber are really yellows is your answer.

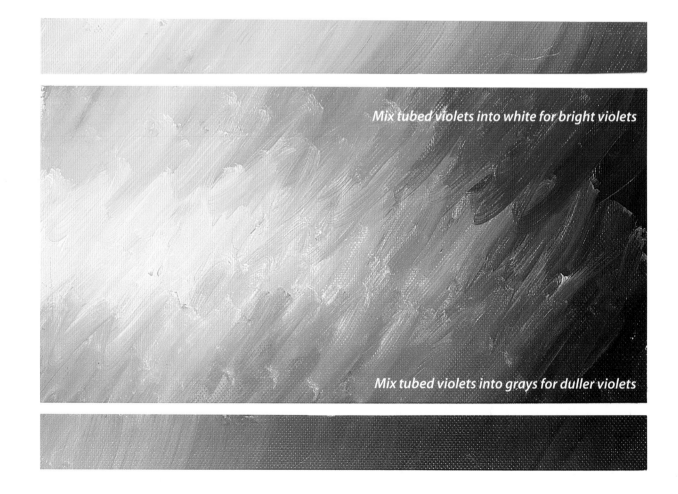

Mix tubed violets into white for bright violets

Mix tubed violets into grays for duller violets

A Color as Well as a Shadow

Bill Roche was an electrician in town, hence the name *Electric Bill* for my portrait of him. Notice the background, reddish violet gradated down in color with darker yellows. I chose it because, for some reason, I thought it would suggest "electricity" as well as fitting his personality. I rejected other background colors for the following reasons:
1) I couldn't use a warm-gray beige because of his hat, vest and pants—all yellows. 2) I couldn't use blue because it would have been boring to repeat the color of his shirt, even with a very grayed blue. 3) I didn't want to use gray either for fear that it would be boring too. 4) I couldn't use tones of orange, a bad idea in any portrait, because they never give skin color the chance to look real. 5) Red was a possibility which I considered using, but, as you can see, reddish violet was my final choice.

Medium violet, shadowed with Burnt Umber

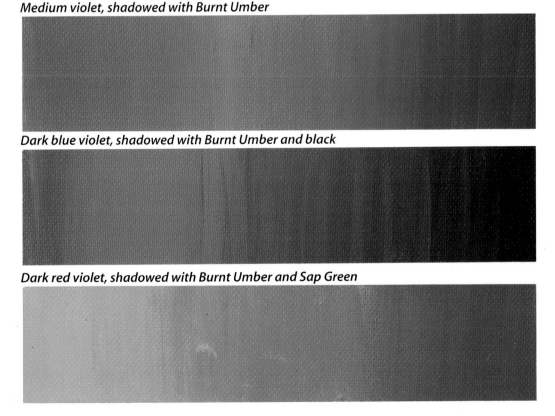

Dark blue violet, shadowed with Burnt Umber and black

Dark red violet, shadowed with Burnt Umber and Sap Green

The Other Tubed Violets Compared to Alizarin Crimson

Alizarin Crimson is a wonderful violet color. In fact I have devoted a whole chapter (Chapter 14) to this color.

Thalo Red Rose. A lighter, more intense red violet than Alizarin Crimson. I do use it on my palette although it is not a workhorse violet; its transparency makes it weak in admixture with more powerful colors. I use it mostly when I paint flowers since its intensity really sings when mixed with white.

Manganese Violet. A dark and lower intensity violet, bluer than Alizarin Crimson. I use it on my palette primarily as a complementary violet to shadow yellows. It makes wonderful dark flesh colors when mixed with Burnt Umber. I love this color because tones of violet are my favorite of the cool colors.

The following violets are ones that I hardly ever use:

Rose Madder—Much like Alizarin Crimson, only weaker.

Thio Violet—Much the same as Thalo Red Rose, only bluer.

Ultramarine Red—A very weak, low intensity blue-violet. Use it more as a gray.

Cobalt Violet—A bit more intense than Ultramarine Red.

Mars Red—Very opaque, low intensity reddish violet.

Helpful Hint

If you paint a lot of flower pictures, search the paint display rack at your dealer for violets. All the manufacturers produce a variety of violets; you could use all the bright ones you can find.

ALIZARIN CRIMSON

Many awful looking mixtures come from trying to use Alizarin Crimson as a red alone. It is not a red, it's a violet. If you think that Alizarin Crimson is a red and you want it lighter by adding white, you'll get the color of the apple that did poor Snow White in. All colors' true identity are exposed by mixing them with white. When Alizarin Crimson is used in admixture with other reds, it is a red color, but as soon as the mixture contains some white, the mixture will turn violet. Alizarin Crimson is a very versatile source of violet. Here are some facts about Alizarin Crimson:

1. It is very dark in tone yet very brilliant in intensity. When mixed with degrees of white, it makes tints of violet.

2. Even more versions of violet can be mixed by adding Alizarin Crimson to tones of gray made of black and white.

3. The only time you can consider Alizarin Crimson a red is to add it to a red such as Cadmium Red Light, Grumbacher Red or Venetian Red.

4. Alizarin Crimson is extremely transparent which makes glazing with it a veritable pleasure.

5. Shadows of black, white and Alizarin Crimson make the violet color that shadows tones and intensities of yellow. A version of this mixture will have to be made often because yellow and yellow green are predominant colors in nature.

Alizarin Crimson tinted with white.

Alizarin Crimson and Thalo Green lightened with white.

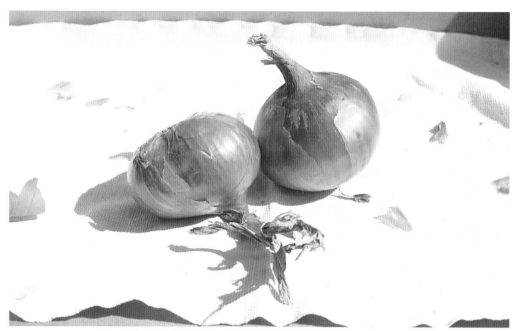

Figure 1

Step 1

FIGURE 1. The setup.

STEP 1. This stage has nothing to do with color but it does have a great bearing on the successful artistic interpretation of the onions. Notice how all the spaces between the onions and the canvas's edges are different. Try not to make monotonous equal spacing.

STEP 2. Your drawing doesn't have to be beautifully rendered; it's important, however, to draw in a subject because to do so will make you inspect your subject's shape.

STEP 3. I painted in a light background behind the right onion so I could judge the tone and intensity of its reddish violet color made of white, a touch of black and Alizarin Crimson. I used this color to mass in the onion but I did not paint it in the highlight area. See Diagrams A and B on page 74 for my procedure of application of the tones of the highlight area.

STEPS 4, 5 & 6. The finished painting. After finishing the onion I overlapped the one on the left over it and painted in much the same fashion. The shadowed tones on the onion are Alizarin Crimson, Grumbacher Red and a bit of Thalo Green and Burnt Umber (the Burnt Umber made the green yellowish, more complementary to the violet color of the onions). With light tones of Alizarin Crimson mixed with Grumbacher Red and white I laid in the groundwork for the highlight. Working across and blending in the opposite direction, I added the highlight of white and a tiny breath of Burnt Umber (a dull yellow that's complementary to violet). The sprout end of the onion was just suggested at the very end of the painting session.

Step 2

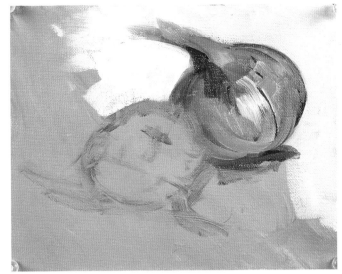

Step 3

The Finished Painting

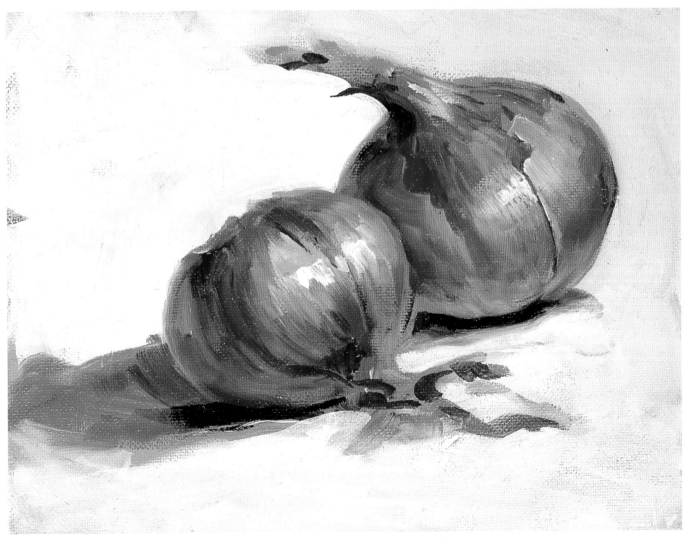

Steps 4, 5, 6

Diagram A

DIAGRAM A. This shows the direction of brush strokes to lay in the basic tones and colors of the onions. These strokes of color should not be blended in. In fact, some spaces between the colors will, in the end, help the onions to look brighter in color.

Diagram B

DIAGRAM B. This shows the brush-stroke direction that does blend in the colors. If this procedure isn't successful, your only recourse is to wipe it all off and start over.

THE COLDEST COOL COLOR: BLUE

I can safely say that blue in large areas is the most difficult color to paint. Maybe that's why the English school of painting, Gainsborough aside, said blue should be used just as an accent color to be used here and there.

Blue is the coldest color of the spectrum. Its hue tendency can only tip toward the two other cool colors, violet and green. It stands to reason that it is the complement of orange, the warmest color.

The coldness of blue is what poses the greatest painting challenge, especially as seen in the light. The presence of light is automatically the presence of warmth; we all feel warmer in light than in shade. Therefore, when you see a cold color in light you have to warm it up. If you don't, it will look flat, raw, stark. You don't want that, do you? Blue's complement—orange—has to come to the rescue to warm it. This is difficult to do without darkening and dulling the blue or turning it green.

It's a dilemma, all right, having to paint a warmed cold color; it's what makes painting such a challenge for the landscape painter, who realizes that blue is such a suitable background color.

When painting somewhat large areas of blue, *handle with care!* A little goes a long way toward making it look too blue and once you have painted it in too strongly, it's pretty hard to kill. It's much better to sneak up on the blueness of the area in question. This can be done by first painting in the area with a gray made of black and white and a bit of orange (Bunt Sienna) in the tone that's a little lighter than the blue area is to be. Then, ease blue into it.

The blue of skies is easier to create if you first paint the area with white and Cadmium Orange. Then, disperse blue and white in dabs into that coverage.

I strongly suggest that you do the following experiment with the color blue (it will teach you how important it is to incorporate orange with it): on the upper part of a 16 x 20 practice canvas, paint an area about 8 x 12 of blue that's made of white and Thalo Blue. Then, on the lower part of the canvas, paint splotches of a very light mixture of Cadmium Orange and white, leaving spaces of bare canvas where you can paint in the mixture of Thalo Blue into lots of white. With a large, dry brush blend the orange areas and the blue areas and work them together. Step back to view these two painted areas from a distance and compare their appearance. See if the lower one doesn't look more "real" blue instead of "painted" blue.

The Most Difficult Color in Nature

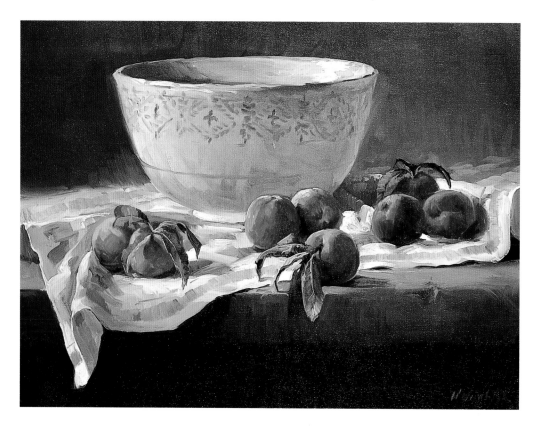

I balanced the blue pattern on the bowl by adding a blue stripe on the white towel. These two touches of blue serve to surround the peaches and accentuate the interest in the picture.

Many blues can be made by their admixture with white and with light or dark grays.

▲ *Thalo Blue and white*

▼ *Thalo Blue and black and white*

Painting the Color Blue

The color swatch on the left shows how raw a gradation of blue looks if the complementary color, orange, is not used in conjunction with it. The swatch on the right was done with mixtures of blue and orange, made of Thalo Blue, white, Burnt Umber and Burnt Sienna. You can see that the background in Rachel's portrait is more like the swatch on the right than like the one on the left.

Using the Color Blue

I found this little pitcher in Fiesole, a town near Florence. Here again, I repeated the blue on the white cloth. The top swatch shows how using a bright blue to shadow orange will turn the orange green. The lower swatch shows orange being shadowed by gray blue (Thalo Blue, black and white).

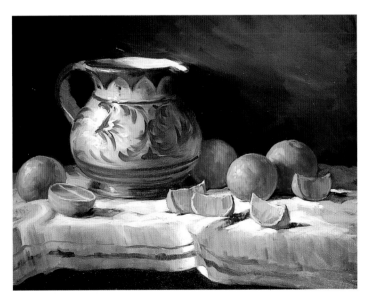

The Other Tubed Blues Compared to Thalo Blue

Thalo is the proprietary name of M. Grumbacher, Inc. for the pigment **phthalocyanine**. Winsor & Newton's version is Winsor Blue, Shiva's is Shiva Blue, and Liquitex (formerly Permanent Pigments) chooses to call it Phthalocyanine Blue. Any one of them is ideal to use as a basic source of blue; blues made from phthalocyanine are transparent, intense and dark. You can make tones from light and bright (Thalo into a lot of white) to darker, brighter blue (Thalo into less white). Duller tones of blue can be made by mixing Thalo Blue into tones of gray, made of black and white. In fact, most of the hues of the other tubed blues can be emulated by Thalo Blue in admixture with grays and colors.

Prussian Blue — Very much like Thalo Blue. Darker, slightly greener and duller. Very intense, very transparent.

Ultramarine Blue — Also called Permanent Blue in some oil color lines. A violety blue. Not as dark in tone as Thalo Blue and not as strong. Very transparent. Handy for skies in landscape painting and to mix with yellows for various shades of green

Cobalt Blue — Lighter, less intense than Thalo Blue. Rather strong and not very transparent. It can be matched by mixing Thalo Blue, white and a touch of Burnt Umber.

Cerulean Blue — A light opaque blue. It might be handy to include on your palette along with Thalo Blue because it's much lighter than Thalo. However, you can match Cerulean Blue's color by adding to Thalo Blue quite a bit of white, Burnt Umber and a mere touch of Thalo Green.

Payne's Gray — Actually, a dull, dark blue that's handy when mixed with yellows, for landscape greens.

Helpful Hint

The most common and obvious use of blue is for water and skies. The most common mistake in painting them in these areas is to make them too blue. You have learned how to control a color's intensity by using gray or the color's complement. When painting water and skies, make sure you realize that the flat of the canvas is where you are trying to record miles of sky and water. Their tones and colors, therefore, have to look far away and close by. Judge the tone and intensity of the far-off water by comparing it to the water in the foreground. To make your skies look more dimensional, look at the color of the sky directly above you and incorporate it into your sky's color at the top of your canvas.

THE WARMEST COOL COLOR: GREEN

Green has a wide range of tone because it's a mixture of a dark spectrum color—*blue*—with the lightest color of the spectrum—*yellow*. Its range of intensity is also extensive. Green's temperature can vary from very cool blue greens to very warm yellow greens. Probably green's vast scope of hues, tones and intensities is why so many students wail,"I have a lot of trouble mixing the right green."

Most of the greens seen in nature are yellowish in hue. For this reason it's better to add amounts of a tubed green paint into a yellow instead of adding yellow into green.

There are may tubed greens from which to choose. Thalo Green's very dark tone yet brilliant intensity makes it the most versatile one of them all in admixture with other colors. Being very dark it never needs to be darkened, yet offers the wide range of tone by additions of amounts of white. Its blue hue can be yellowed with many different yellows: Thalo Green and Burnt Umber for dark yellow green to Thalo Green and Cadmium Yellow Light for light, bright yellow greens. Even lighter versions of these greens can be made by adding white to them. A tubed dull color can't be intensified and it confers its dullness on everything with which it's mixed. Thalo Green's beautiful, strong intensity can be dulled, muted and toned by admixture with its complement, red. Therefore, the more intense tubed color is, the more versatile one to use in admixture.

Thalo Yellow Green is such a handy color to have to supplement Thalo Green, since it is so light and yellow in relation to it. Sap Green, too, serves as a convenient supplement to Thalo Green, because of its more medium tone and intensity.

Blue greens are seldom seen in nature. They play decorative roles but are often seen in skies. In fact, if you were to add a mixture of Thalo Green and white in patches to a sky, you would lend a warm relief to a sky that looks too blue.

Green is often referred to as nature's background color, and can be used often as a background color for flowers, still lifes and portraits. Especially suitable are the greens that are medium in tone, yellow in hue and muted in intensity. These types of greens can be mixed by adding Thalo Green into a tone made of black and white and then adding one of the oranges of the palette: Cadmium Orange, Raw Sienna or Burnt Sienna. Very grayed versions of these types of green can also be made by adding a little red into the mixture.

Since most greens are yellowish ones, you'll have to use red violets as their complements to gray or shadow them.

Shadowed Greens

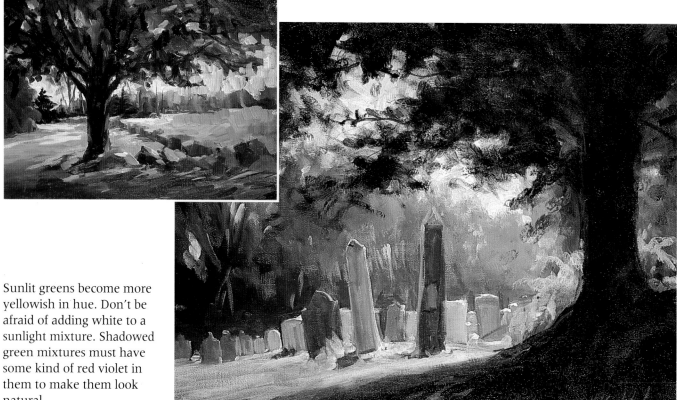

Sunlit greens become more yellowish in hue. Don't be afraid of adding white to a sunlight mixture. Shadowed green mixtures must have some kind of red violet in them to make them look natural.

Thalo Yellow Green and white — Thalo Yellow Green, Sap Green and Alizarin Crimson

Sap Green, Yellow Ochre and white — Sap Green, Yellow Ochre and Alizarin Crimson

Yellow Ochre, Thalo Green — Thalo Green, Burnt Umber and Alizarin Crimson

Landscape Greens

If you paint a scene where there are a lot of greens, search out the darkest one, compare it to the lightest one and mix both tones next to each other on your palette. This is the best way to stop you from making all the greens the same—for instance, the green of the evergreen tree compared to the sunlight on the grass.

Tones of Thalo Yellow Green and white

Tones of Sap Green and Cadmium Yellow Light

Greens made of Thalo Green or Sap Green and orange

Greens made of Thalo Green or Sap Green and Burnt Sienna

Helpful Hint

You can avoid making your greens too green by always adding the tubed greens into puddles of yellows and oranges. When making greens out of yellows and blues, add blue into a puddle of yellow.

Other Tubed Greens Compared to Thalo Green

All the information about Thalo Blue also applies to Thalo Green. It's a trade name, it's transparent, dark and intense. In admixture with tones of gray, many lively hues of blue-green can be made. The difference between Thalo Green and Thalo Blue is that green colors get more yellow in hue as they get brighter; to lighten and brighten Thalo Green, white and yellow have to be added to it instead of adding just white.

Thalo Yellow Green — Very light and very yellow. I love this color because it's so opposite from Thalo Green.

Sap Green — Although I can mix this hue with Thalo Green, Burnt Sienna, Cadmium Orange and white, I find a tube of Sap Green handy, enjoying the transparency that's not possible with my homemade mix due to the addition of opaque white and opaque Cadmium Orange.

Viridian — Lighter in tone, less intense and yellower than Thalo Green. Mixed with any of the yellows, Viridian makes grayer versions of the ones that Thalo Green and yellow make. Transparent but weak in covering power. Thalo Green is more economical to use than Viridian because in admixture, a little Thalo Green goes a long way.

Permanent Green Light —An opaque, more medium-toned green than Thalo Green. I never use this color. It makes sense to me to have the darkest versions of color on my palette because I can always make lighter versions of them by adding white.

Chromium Oxide Green — A very opaque green which makes it very strong in covering power. Mix with Burnt Umber, Burnt Sienna, Yellow Ochre, Cadmium Orange or cadmium yellows for natural looking greens. Good for painting outdoors.

Green Earth — Although the colors look somewhat alike, Green Earth's characteristics are just the opposite of Chromium Oxide Green. Green Earth is very transparent and very weak. Not at all suitable for landscape painting even though it's **earthy** looking. Green Earth is used mostly by the portrait painter who needs to make fragile changes in flesh mixtures.

THE COLOR GRAY

Gray really can't be called a color; it's a *condition* of a color. We see grayed versions of all the colors in many, many tones. There are, however, as you are aware, some things that we can actually call *gray*. One of them, the most obvious for the still life painter, is pewter. The most obvious example of a gray in nature is fog.

Gray, though, imposes a much deeper importance in painting than recording pewter and fog; it has the capacity to make our paintings look atmospheric and our colors look real. When color mixtures are infused with their complements, a special kind of gray condition makes the mixture more suitable looking. Using warm and cool colors next to each other, through the use of a color and its complement, imparts the gray condition that looks right. To explain:

1. **Red Apple** — Its highlight is *cool green* on the *warm red* body tone. The edge of the shadow is *cool green* and the shadow itself is *warm red*.
2. **Skin** — Its highlight is *cool* flesh on *warm* flesh. The shadow's edge is *cool*; the inside of the shadow is *warm*. The cast shadow's color is *cool* with *warm* color in it.
3. **Sky** — Blue warmed with orange, making its color atmospheric gray.

As you can see in the examples cited, there is a condition of grayness that's important to rendering the realistic color of things. My very simple color mixing advice is: *When in doubt use gray* for those doubtful-looking colors. Beautiful ones can be made by mixing black, white and a color. Beautiful grays are known to be made by mixing a color and its complement. And those who refuse to use black will have to do a lot of mixing of the two colors into amounts of white to adjust the mixture's tone value. I think it is easier to establish a tone value of gray with black and white and then impart a color into it. After all, by now you realize that the tone of the color is extremely important. Doubtful-looking colors are usually the ones affected by shadow. I find the use of black in admixture makes getting the right tones of colors easier. I can do so without a lot of experimental mixing which has a tendency to deaden mixtures. I'm aware that the purists will not use black; I do, and just gave you good reasons why.

On the other hand, there is no doubt about those colors seen unaffected by shadows and they shouldn't be mixed into gray. Definite colorations are usually seen in light so a somewhat oversimplified formula for colors in light is color into white.

These mixtures are best made by moving an amount of white into the mixing area of your palette and adding color to it. The mixtures will sparkle more if they are not over-mixed.

Some words of summation: Colors in shadow are colors into gray; colors in light are colors into white. Is color mixing that easy? In a way, yes.

Gray is Everywhere . . .

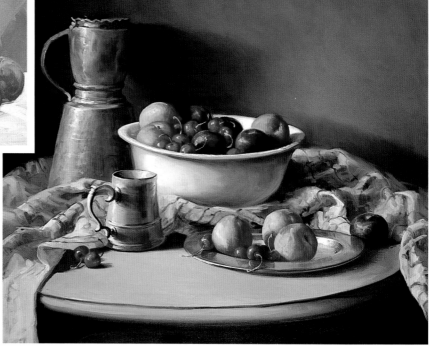

The arrangement of fruit with gray background and tankard shown above is a simplified version of the more elaborate still life. I did it (the simplified one, that is) on my television show to demonstrate how gray shows off color. I find that students swamp their paintings with too many colors instead of balancing the presence of color with somewhat colorless areas.

Warm colors are grayed with cool colors.

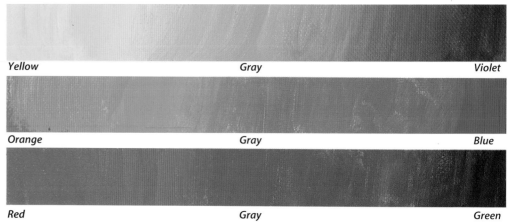

Yellow — Gray — Violet

Orange — Gray — Blue

Red — Gray — Green

Gray is Warm and Cool

Cool colors are grayed with warm colors.

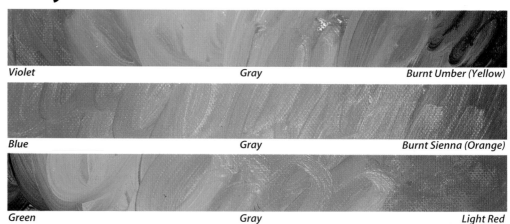

Violet — Gray — Burnt Umber (Yellow)

Blue — Gray — Burnt Sienna (Orange)

Green — Gray — Light Red

Gray is Colorful

Foggy weather, misty meadows, fuzzy peaches, hazy mountains, dewy grass. Paint's answer to these effects is GRAY!

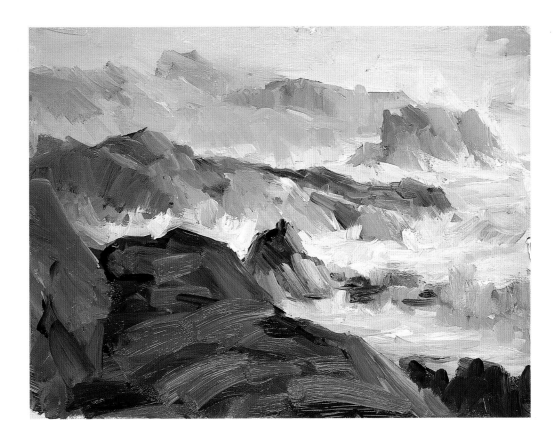

Various warm colors into black and white. *Various cool colors into black and white.*

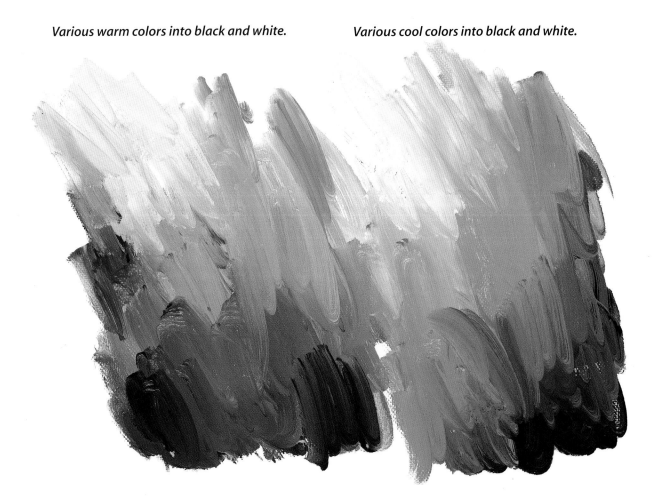

Tubed Whites

Tubed whites — lightening agents for color:

Zinc White — A clean tinting, slow drying white. The portrait painter's favorite.

Titanium White — A strong tinting white, suited to all types of painting.

Flake White — A very heavy white white. Has to be greatly thinned for ease of application.

Soft Formula White — Permalba White, Superba White, Winsor White, Ultrawhite, are all commercial names for juicy whites made of zinc and titanium combined. There are many trade names for whites that are all reliable. Use one that's fluid and soft enough to mix easily with your colors.

Technical Helpful Hint:

Since white is very slow drying, it should be used mostly in the finalizing mixtures. This is easy to do because the lightest light tones are best added last.

Tubed Blacks

Black — the darkest tone of paint available:

Ivory Black — A neutral, clean transparent black. The only one I use.

Mars Black — A warm, opaque black. Too overpowering to use with colors.

Lamp Black — A cold, very opaque black. Too overpowering to use with colors.

Mediums

My Mediums—For general painting, I use turpentine. It's not that I actually mix it with my paint; I dampen my brush with it to ease its flow on the canvas. My brush is constantly damp from cleaning it in turpentine between mixtures. If I have to thin my mixture, I use a medium made of linseed oil, damar varnish and turpentine (equal parts of each). I use this medium to thin my paints for glazes. Painting outdoors, I add some linseed oil to the can of turpentine. I clean my brush in this from mixture to mixture; it makes my mixtures more spreadable.

At times, I will apply paint with painting knives for effects that I think are easier to get than with brushes, like stroking flashes of sunlight or lines seen in books or rooftops or masts on boats. Painting knives (or palette knives, as some people refer to them) only apply light tones well because light tones are thick. Many beginners find knife painting fun; and their paintings look better than the ones they do with brushes mainly because **they use more paint**.

CHOOSING COLORS FOR BACKGROUNDS

So far, we have examined color and color mixing for subjects. I like to refer to subjects as positive space. What's left over on the canvas is negative space, usually called *backgrounds*. For the important role that backgrounds, or negative space, play in pictorial interpretation, one would think that they should warrant even more thought and concern than the color of the subjects.

First, they determine the body tone or mass tone's color mixture. You always have to see what the tone of the subject is in relation to its background.

That is the most practical element of backgrounds. But the role they play in a painting is quite profound. They record theme and mood, atmosphere and space. They are difficult to paint because they are not subjects to look at and refer to. They have to be tastefully imagined. The next few chapters might awaken in you a better awareness of backgrounds.

I decide background colors by a process of elimination. I begin to examine the possibilities. My first limitation is the color's tone:

I can't easily use a light background for a lightly colored subject or, it follows, a dark one for a dark colored subject. And medium-toned colors, such as reds and violets, can't withstand medium-type backgrounds. I also consider the subject's intensity of color, ruling out bright backgrounds for bright colors, and dull ones for drab subjects. I don't rule out completely the same color as the subject. In fact, it is a safe choice. Of course, it must be a contrasting tone to the tone of the subject, and the intensity of the color should be greatly changed.

A successful-looking background depends more on how it is executed than on its color, especially the ones that are a tonal gradation from light to dark.

There are three major areas of backgrounds that warrant your attention:

1. *Where it meets the subject.* Overlap the paint into the subject's edges instead of to its outline. This area of a background has to look as though it continues around and in back of the subject. The subject's shape can be repaired later.

2. *Where it meets the canvas edges,* calm down any activity of tone, color and brushwork.

3. *The space between the subject and the edges of the canvas.* This area should join interestingly. The best way to deal with it is not to have much of it. If your subject is so small that there is a lot of background, the best cure is to cut the canvas down in size.

Types of backgrounds are largely a matter of personal taste.

I feel that a background should continue the spirit of the subject: dramatic people, dramatic backgrounds; earthy subjects, earthy backgrounds; elegant subjects, elegant backgrounds.

Roughly painted subjects should have roughly painted backgrounds. Conversely, smooth backgrounds for smoothly rendered subject matter.

I always prefer warm backgrounds, either actual warm colors or warm versions of cool colors. I do so because I feel that the warmth of the light shining on my subject must also influence the color of my backgrounds.

Don't be afraid of mixing color into puddles of black and white for a background. It imparts that toned-down quality that a color needs to be a background color, your mixture will have good covering power and it will withstand additions of color and tonal adjustments.

Backgrounds and Their Brushwork

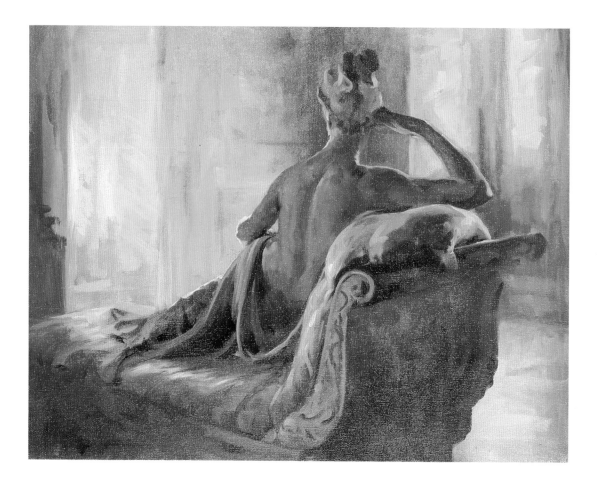

In the Borghese Gallery in Rome there is a magnificent —and courageous—work of art, a marble statue by Antonio Canova (1757-1822) that he called *Conquering Venus*. The sculpture is a life-sized likeness of a nude Pauline Bonapart Borghese, the sister of the French dictator, and is a superb example of the **neo-classic** style of art. It is lovely from every view, an example of Canova's artistic taste and expertise as a sculptor. As painters, you have to marvel at sculptors composing in the round, since many of you have enough of an artistic struggle with but one view of the subject. I've seen this Canova masterwork many times, each time impressed by the tender interpretation of her cool, aloof beauty. Using photographs of the statue, taken on our most recent visit to Rome, I painted this view.

In this book on color mixing, I've tried to concentrate my teaching on practical, useable information, hoping that it will help you paint better and find more satisfaction in your efforts. Since I don't know what subjects you are interested in painting, I hardly can give lessons on how to paint, let's say, a moose, or a lit candle, or the sun coming up over the ocean waves, to cite but a few of the many kinds of paintings that I've seen others paint. It is up to you to apply your understanding of the basic painting principles and techniques in your choice of subjects. With this in mind, may I suggest that you make your artistic career more a pursuit of **how** you paint rather than **what** you paint. We admire the great masterpieces done by the great painters of the past because of their wonderful interpretations and pictorial presentations, sometimes even finding their subject matter not that appealing.

It's hard to paint the ordinary and common let alone trying to paint the exotic and unfamiliar. I hope this directs you to be inspired to paint things that you know, see and experience. If you have to reach into your imagination instead of your educated memory, your subjects will look like imaginary people, places and things instead of artistic interpretations of them.

Backgrounds from Light to Dark

A realistic-looking gradation of color from light to dark is not done by just lightening one color. That type of gradation will look flat and raw. In nature all colors are influenced by the three colors in light. So it's logical that three colors have to be used on canvas, too. See how the yellow and violet in "A" alternate as the tone darkens; it's the color-and-complement theory again in practice.

These bands of color were then blended together, as seen in "B". When grading a background from light to dark, always start with a light tone of the actual color, then add its complement into that puddle, then into **that** puddle, add a darker actual color, then darker complement color, and so on and so on until you reach the edges of the canvas. **Great fun!**

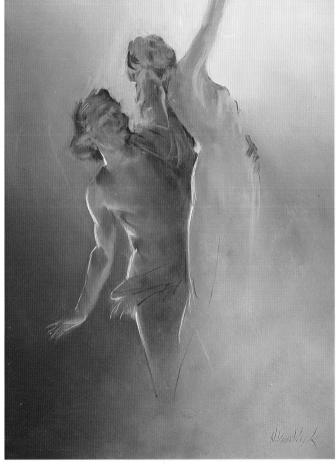

Why the Background is Dark Where the Light Comes From

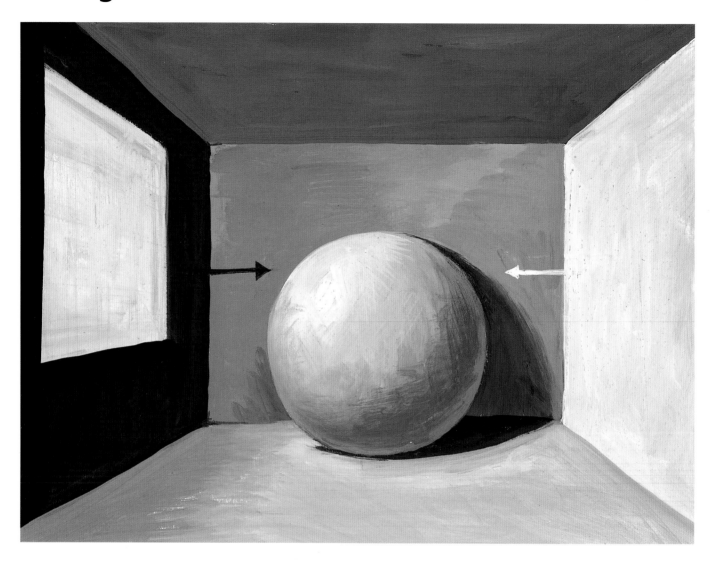

Back to the ball for another lesson on basics, this time to help you understand why backgrounds are dark on the side of the canvas where the light comes from. The color and tone of the background that you see immediately adjacent to your subject does not have to be the color you use for your painting's background. Your background area can be more inspired than that; inspired by the fact that you want your background's colors and tones to suggest space. You can accomplish this by incorporating the tones of the entire room into your backgrounds. Do so by using the dark tone of the room against the light tone of the subject, and the light tone of the room against the dark of the subject. Arranging tones this way in the background area makes it essential to know how to grade a color from light to dark.

COLOR AND THE FOCAL POINT

A focal point is the sum and substance of pictorial composition; it is often referred to as the **center of interest**. Before examining how color serves as a focal point, there are some elementary factors about this area of your picture that I should restate. They are:

1. The focal point should never be in the middle of your canvas.
2. There should only be one focal point per picture.

By realizing the importance of the focal point, you should make all the colors of its surroundings respect its importance. I like to refer to the focal point and its surrounding area as positive and negative space. These designations make me consider the focal area as a place for positive colors, positive shapes, positive contrasts in relation to the supportive—less dominant—colors, tones and shapes of the focal area's surroundings. It's elementary that in order to make your color mixtures of the negative spaces supportive, the positive colors of the focal area have to be established first. I'm not saying that it's the very first thing done on the canvas. Most often, after the composition is set down, a background of tone and color has to be painted in so you can then start to paint the focal area in shape, tone and color. The positive and negative spaces are like balancing a see-saw, you work on one area, then the other. It's this thinking that directs your color mixtures to tip the power of your color on the focal point side.

Oddly enough, the areas of the canvas that can serve the focal point well are its four edges. That's where the picture's interest comes to a complete halt. Take care how shapes, tones and colors meet the edges: fuse the colors, darken the tones and **never** let shape just touch the edges. Once you realize the radical difference of these two areas, you will relegate the area between them as intermediate in interest, and should paint it accordingly.

It's impossible to give you definite instructions about color in the focal point. All I can do is caution you to always have the focal point uppermost in your mind during your picture's development. The attention and concentration that's needed to paint the entire area of your canvas can mislead you into using colors and tones that, in their final appearance, do not benefit the overall presentation of the subject. A way to notice if this is happening is to step back so you can view your work from a distance. It's the best way to see if the focal area's importance is being invaded by distracting elements.

In this chapter I explain how I deal with the focal areas in my paintings. I hope it will give you some insight about pictorial dramatics.

Don't Center Your Interest

Single Out a Shape

This painting, done on my TV show, reveals the simplest way to establish a focal point. Interest is focused on the cylindrically shaped pewter tankard by the many cube-shaped books. The tankard's gray color is singled out by the colorful red book behind it.

Helpful Hint: Contrast colorless with colorful. Colors on color fight for attention and are not that easy to paint.

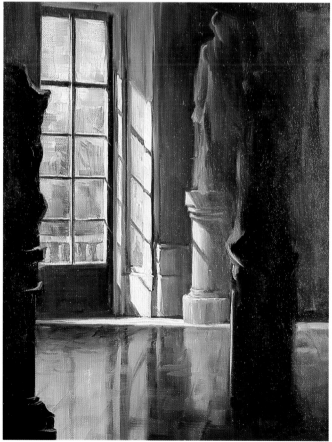

Like bugs seduced by a lamp in the summer night, we too are attracted to the light. At least, I know that I am. While visiting the Capitoline Museum in Rome, the light from the window shining on the wall and marble floor caught my eye. I located the light patterns surrounded by dark in the lower left of my canvas. The look of the shiny floor has provoked interest and the question, "How did you paint it?" I painted the tones of light reflecting on the floor in downward strokes and left them to dry. Then, I applied a gray greatly thinned with medium over this area which semi-obscured the reflections, giving the area a feeling of a surface.

Single Out a Contrast

Find a Center of Interest

Focus on a Thing

The thing about *Ketchopulos Market* that fascinated me was the pole in the foreground with its flag, surrounded by an abundance of produce. I painted this area more carefully than its surroundings. Even though you are aware of the entire building, your attention is arrested by the focused area. Emphasize the thing that attracted your attention with paint. Don't distract your viewer's attention from it by too much detail and contrast in the outlying areas.

The painting of an old pail and blueberries is an example of how a focal point does not necessarily have to be an object. In this painting, the focal point is the area where the berries hang over the back of the pail. Interest is very much localized in this area by the bright colors of the leaves and berries and the light on the pail.

Focus on an Area

Atmosphere . . .

I initially invest atmosphere into my color mixtures by not painting any of the dark tones as dark as they are, and not recording the light tones as light as they are. I save the actual tones of light and dark to accent the area I want to come out in sharper focus. I repaint some of the already light areas with even lighter light mixtures, such as on the daisies located above the vase, on the vase itself and on the table around the vase. Doing so relegates the initial mixtures used on daisies, vase and table to be atmospheric.

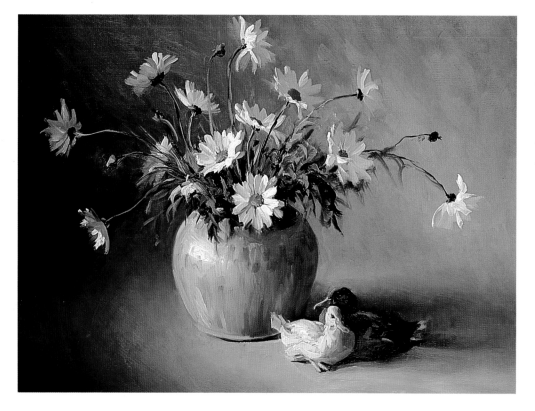

A gradation of color from light near the subject to dark and grayed near the canvas edges is another way to implant a subject in atmosphere with paint.

. . . and Space

All the fruit in this painting appear more up front without much atmospheric influence because I added lighter, crisper colors on the positive area of the composition which extended quite near to the side edges of the canvas. The feeling of depth in this picture adds the atmosphere and is due to the fact that all the subjects overlap each other, from the watermelon slice to the front folds of the cloth.

The composition of grapes as a subject is unlike the watermelon painting because I made the light focus not on the subject but on the area surrounding the grapes and leaves.

In all four paintings, the focal area is just off center. In the flower paintings, the upper left; in the fruit ones, the lower left.

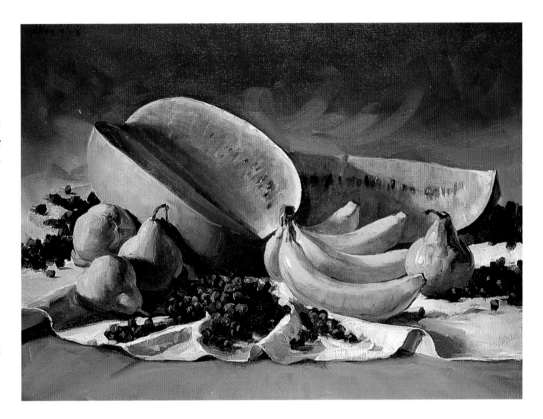

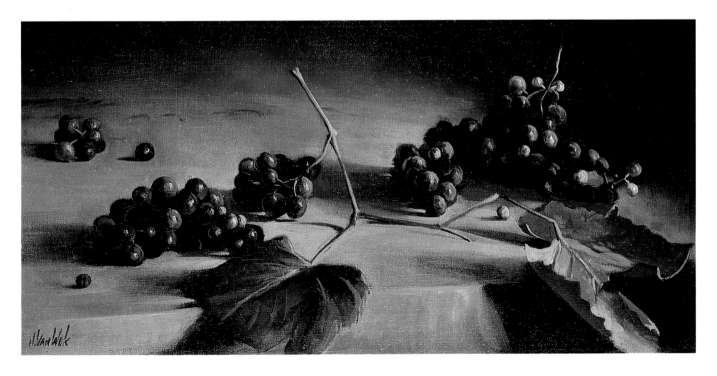

A Subject's Dramatic Advantage . . .

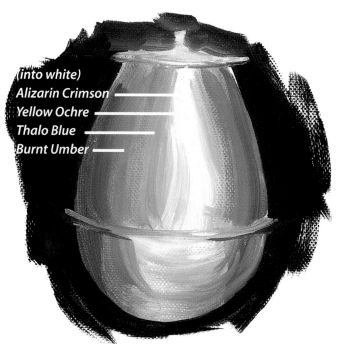

(into white)
Alizarin Crimson
Yellow Ochre
Thalo Blue
Burnt Umber

A silver object is so shiny that its surroundings reflect onto it dramatically. These alluring reflections are usually seen in the object's shadows, but don't let them lure you into making them as light as the object's highlights. The swatch shows the important highlight that describes the pot's roundness, a factor that's just as important as the object's shine.

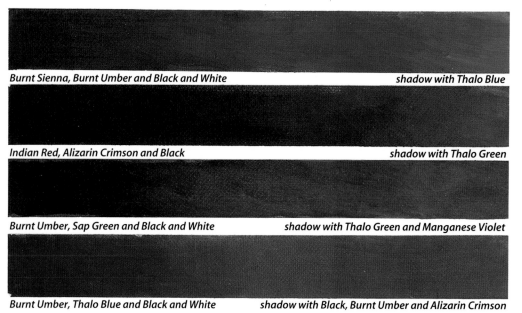

Burnt Sienna, Burnt Umber and Black and White — shadow with Thalo Blue

Indian Red, Alizarin Crimson and Black — shadow with Thalo Green

Burnt Umber, Sap Green and Black and White — shadow with Thalo Green and Manganese Violet

Burnt Umber, Thalo Blue and Black and White — shadow with Black, Burnt Umber and Alizarin Crimson

Since subjects so often cast shadows on backgrounds, dark background mixtures have to be light enough in tone to be able to shadow them with their colors' complements. Dark backgrounds look more luminous if they are done with two thin coats of paint than with one thick coat.

Dark Subjects Need Light Backgrounds

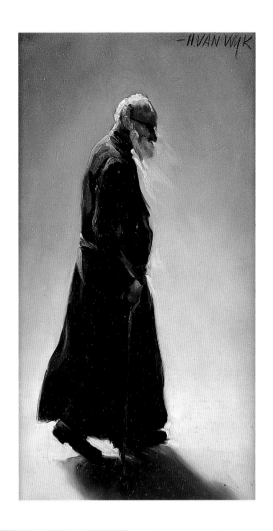

Dark subjects look best silhouetted against light backgrounds. Their shapes can be nicely rendered by painting the background color into the subject's shape and then moving the color of the subject back out into the background color either sharply delineated or blended. These found-and-lost edges con- tribute greatly to recording the subject's dimension.

Just as white things are not white paint, black things are not black paint. I made the black of both the monk and the dog orange (black, white and Burnt Sienna) with blue-blackish shadows and gray-blue highlights.

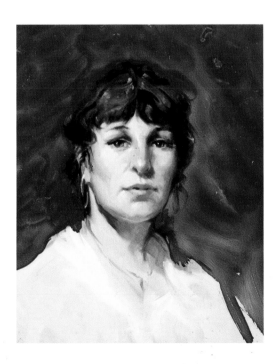

The entire color presenta- tion of your subject, in this case skin color, is influenced by the background. You can see how changing the back- ground on Linda's portrait from light to dark has also changed her flesh color.

Helpful Hint:

This factor can be used as a corrective measure: lighten a subject's color by darkening the back- ground or darken them by lightening the back- ground.

. . . the Painter's Advantage as Well

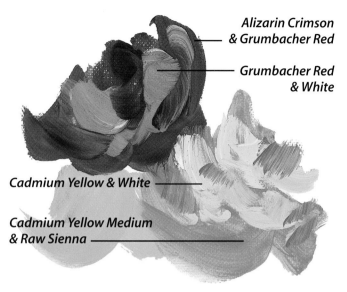

Alizarin Crimson & Grumbacher Red

Grumbacher Red & White

Cadmium Yellow & White

Cadmium Yellow Medium & Raw Sienna

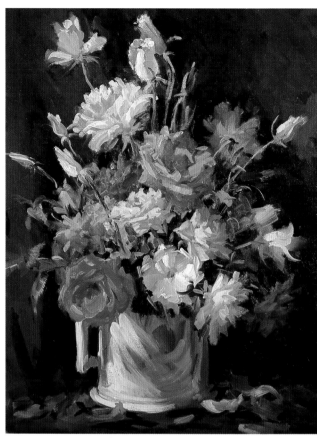

Amounts of white thicken a color mixture and make it one that is easy to apply on top of colors that were more thinly applied. A dark background enables you to lay in a subject's color in a tone not as light as its body tone but not as dark as its shadows. Additions of lighter and lighter color mixtures define the subject as well as making it stand out from the dark background.

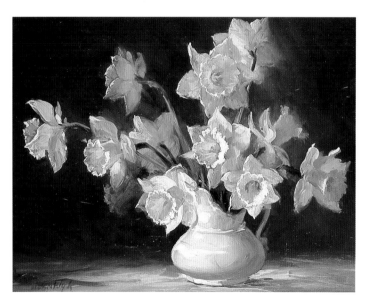

Cadmium Yellow Light

Cadmium Yellow Light & White

Manganese Violet

The delicacy of the daffodil was easier to record against a dark background because its dark tone could be seen through the flower's thin petals, making their mass tone color quite grayed. Shapes of thick, lighter, brighter yellow mixtures were added to the basic grayed mass tone to record the light on the flower and also the light that passed through its semi-opaque texture.

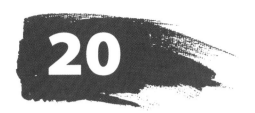

DRAPERY: A POPULAR BACKGROUND

Beautiful renderings of folds of draped cloth can be seen in every art museum. Visitors to the galleries where the formal portraits of the English gentry hang, marvel at the texture and folds of elegant satin and brocade.

The drapery on the figures in the myriad religious paintings of the Italian Renaissance is painted with lively colors, not to mention how accurately the folds conform to their bodies' movements and anatomy. Renderings of cloth in many different compositions seem to have been done with ease by even the lesser painters of the period.

Today, the need to paint drapery well remains. One, obviously, is in portrait painting, where you are always faced with doing clothing and perhaps, at times, when you might like to use drapery to excite or soften a background. In still life painting, drapery is often used as backgrounds or as essential parts of a composition in the form of embroidered or lace table cloths or just plain kitchen towels.

I feel that a chapter devoted to painting drapery can serve two purposes: it will prove that the basic principles of color and tone can be used to render any subject, even the ins and outs of the folds; it will also give me a chance to stress the necessity of using an efficient procedure of color application when faced with a complex, confusing subject matter. All the tones of light and dark that you see on all the folds as they hang next to each other are confusing and if you try to paint all of them in one application, your rendition might well record your confusion. To paint complex subject matter, you must resort to doing it in simple stages of development. I find that I use two distinct applications of paint to record drapery:

1. The first stage records the shape of the shadow areas as one tone. This shadow area is made up of the body shadow and the darker cast shadows, but during this first stage, I paint them both only in one tone of shadow color. Shadow color is relatively complementary to the color it is on. To review: In the case of a red drape, the shadow color would be red, darkened and reduced in intensity by green. I substantially paint in the light areas with the actual color of the drapery (red plus some white). This first stage of painting drapery should not be thought of as a merely preliminary indication to be repainted. The canvas should be completely covered with the tone of the dark pattern and the tone of the light pattern because the additions of paint of the next stage of development never completely covers the first coverage.

2. Now I paint in the lighter tones I see within the light areas with a new mixture, not just adding white to the original light tone mixture. In many cases, it's a highlight-type color. In the case of the red drape I'm using as an example, the mixture could be red, orange and white. I add more red coloration on to the shadowed areas and paint even darker shadow color to record the cast shadows.

Arranging Drapery

B

"Kisses" on canvas result where two shapes just touch. These kisses are detrimental to composition, dimension and the sensibility of the shapes involved. Compare the kissing drapes in "B" to the painting to see why **you can't kiss on canvas**.

If you arrange drapes to hang in sausage-like folds, it stands to reason that you'll paint them to look like sausages. If you arrange folds in a confusing array of meaningless shapes, your painting of them will be more of a distraction than an asset to the composition.

Helpful Hints on Arranging Drapery

1. Try to have an uneven number of folds.

2. Make the folds near the subject the important ones.

3. Don't make all the folds the same width.

4. Don't let the folds go off the edges of the canvas.

Painting Drapery

When I entertain during the spring months, I use this tablecloth with my green dinner china along with a centerpiece of yellow and white daisies. Notice how the folds vary in shape and size and how the shadows contrast the bowl advantageously. It takes me quite a bit of time to arrange a drape, making sure that there are no "kisses," repetitions or confusion. I try to arrange the folds in a way that I can see the five tone values per fold:

1) **body tone**
2) **body shadow**
3) **cast shadow**
4) **highlight**
5) **reflection.**

A general technique for painting a fold is to apply the paint across its shape rather than up and down in the direction that the material falls. Its up-and-down effect is obvious. The less obvious but "oh-so-important" factor of a fold is its in-and-out dimension. Painting the tones of the fold in across strokes permits you to blend them all in with up-and-down strokes. Save the obvious for last. **The first things you see should be the last things you paint.** In this particular drape, the applique and embroidery were added after the folds had dried.

The beginning stage (left) of any painting should record your singular concentration on the placement of your subject. It, and its immediate surroundings, becomes the all-important focal area. Many hours of painting with beautiful color will never correct or compensate for a bad composition.

A practical way to simplify all the tones of drapery (right): By mixing up two puddles of paint on your palette—one for the light tones and one for the dark ones—you'll be forced to see and paint only the two basic shapes, that of light and shade.

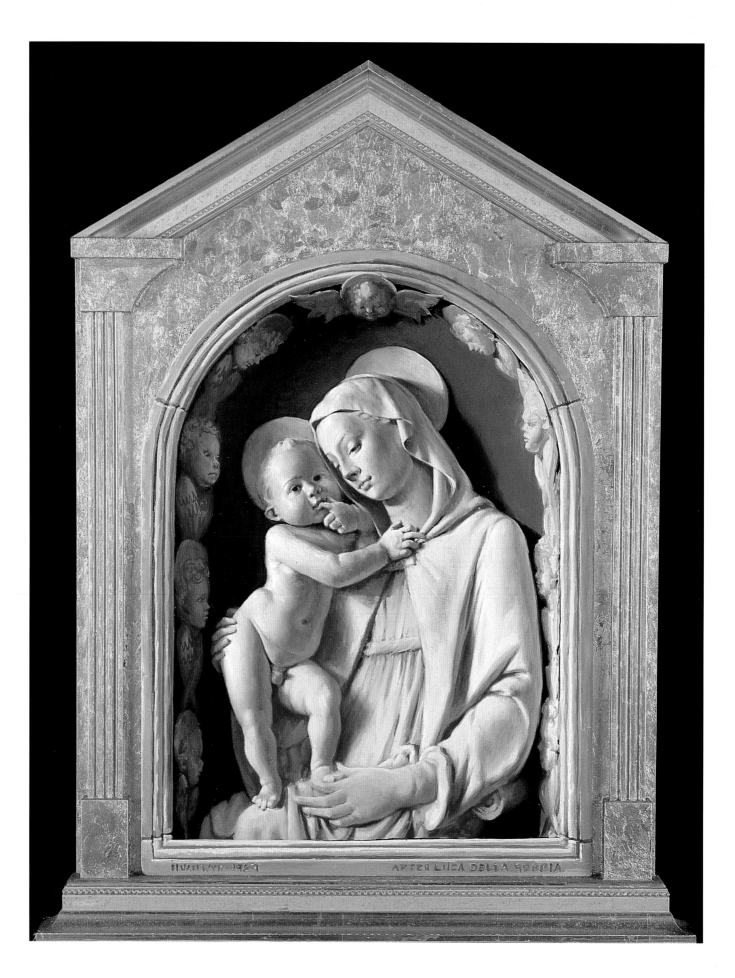

PAINTING THE COLOR OF SHADOWS

If you're like everyone else who paints, you want your picture to record nature's character and beauty. To do so you must realize the difference between real and pictorial. I can still hear Rasko say to me, "Helen, you have the *audacity* to try to paint an illusion of a three-dimensional world onto a mere two-dimensional surface."

You can reconcile this difference by recording the five tone values that nature's light imposes on the things you see. What better way to learn how to record the depth dimension than to inspect how shadows can actually make a form look like it's jumping off a flat surface! Once you can see the two types of shadows—body shadows and cast shadows—you'll have to learn what colors you have to mix to make them look convincing.

How I wish that making the color of shadows was a simple formula! Generally, shadows can be made by mixing the object's color into a tone of gray (black and white) instead of into white, as is done when making the color of the body tone. Although this approach is correct, it's not complete enough to paint beautiful, convincing shadows. To paint both types of shadows (body and cast), you have to learn that they are made up of two parts: their edges and their interiors. The edge is where the shadow is somewhat colorless; the interior is somewhat colorful, depending on the surroundings and reflected light.

Inasmuch as there are two colorations, they have to be painted in two applications. The first one should be a color that's relatively complementary to the all-important body tone. Of course, this mixture has to be also darker in tone than the body tone. Very often, it is made by mixing the body tone's complement into black and white. For instance, the mixture for a shadow on yellow beach sand would be any violet into black and white. When a body tone is not a very light value with little white in it, such as in a red apple, the shadow can be just green (Thalo Green or Sap Green) added to the body tone.

The more colorful quality of the interior of body and cast shadows can be made by mixing the object's actual color into the first shadow tone mixture. Therefore, in the beach sand mixture, Yellow Ochre and Raw Sienna are mixed into the black, white and violet mixture. *Never* use the body tone mixture in the shadows. It is too light due to all its white. In the case of the red apple, the color of the interior of the shadow could be Alizarin Crimson and Grumbacher Red.

Dimensional Shaping with Body Shadows and Cast Shadows

At first glance, my painting of the Della Robbia Madonna looks like a monochromatic rendering with the only display of color being the blue background. In actuality, the painting is in full color, as you will learn from the color mixtures of the five tone values. I've pointed them out and then listed them in order of application.

1. The body shadow on the Infant and His cast shadow combined: Black, white, Alizarin Crimson, Thalo Blue and a touch of Burnt Umber.
2. The first application of the body tone: White, Yellow Ochre, Burnt Sienna, Burnt Umber and Manganese Violet.
3. The second application of the body tone: White, Yellow Ochre and Burnt Umber.
4. The highlight on the body tone: White and Alizarin Crimson.
5. The interior of the body shadows: Black, white, Raw Sienna, Burnt Umber and Burnt Sienna.
6. The interior of the cast shadows: Black, white, Burnt Sienna and Burnt Umber.

7. The reflections in the body shadows: Black, white, Cadmium Orange and Raw Sienna.

The colors of the blue background:
1. Body tone (first application): Black, white, Thalo Blue and Burnt Umber.
2. Body tone (second application): Black, white, Thalo Blue.
3. Cast Shadow (first application): More Burnt Umber and blue into the body tone.
4. Cast Shadow (second application): A little Thalo Blue.

These mixtures model the entire statue even though they are pointed out only on the Infant and His cast shadow. The many places where the yellow body tone meets the violet body shadows are grayish in color because of the blending of a color and its complement. I call these edges "turning points"; they are often referred to as halftones. These gray edges, along with the grays that are caused by blending violet highlights into the yellow body tones, are very important to luminosity and dimension.

THE COLOR OF HIGHLIGHTS

Highlights, those shiny, little spots that contribute so much to a subject's texture and dimension, are seen where light strikes a shape so directly that the shape's color seems to disappear in glaring illumination. As a painter, you make your paint record what light is recording, and light *causes* those shiny spots. Making the color and tone of highlights is a major consideration.

Highlights are seen everywhere. The most obvious and stunning highlights are those seen on silver; more mellow ones are seen on polished wood. We polish copper to enhance its sharp, glowing highlights, while women dust their noses with face powder to actually reduce the highlights. In my book, *Welcome to My Studio*, I told the reader *where* highlights could be found (on the concave and convex planes that are in line with the light). Since *this* book is devoted to color and color mixing, the emphasis here, logically, is going to be on the *color* of highlights:

1. The very light spot type of highlights are always made of a lot of white with just a small dab of color.
2. The more mellow type of highlights are made of a light gray (black and white) with a dab of color.

Some highlights are in stark contrast to the color they are on, such as the ones on glass; others seem to blend into the colors they are on, such as on dull pewter, cheeks and powdered noses.

No matter what type of highlights you want to paint, it should be made of a color that is relatively complementary to the color it is on. Consequently, green bottles have red highlights, brown wood (a form of orange) has blue highlights, blond hair has violet highlights. Mind you, these highlight colors I have just cited are not as obvious as the red of a rose, the blue of a sky, or the violet of a lilac. They are very slightly colored, and are the object's lightest tone value.

A properly colored highlight imparts the beautiful glow that light imposes on color. If you don't use the complement of the subject in your highlight color, the color of your subject will look unreal and raw. The most common color mistake in painting highlights is to just use a lighter version of the object's color, such as a very, very light green on a dark green bottle. NO! NO! NO! If you study a highlight very carefully you have to come to the conclusion that it could *never* be made of the same color it is on and show up as dramatically as you see it. By using a tone of a color's complement for highlights, you balance the temperature of your color presentation, which is necessary for getting natural-looking color. Cool gray-blue highlights on warm brown-colored hair will make the hair look naturally shiny. On the other hand, lighter tones of brown for highlights wouldn't.

I'd like to point out that highlighting a color with its complement is not an iron-clad rule. There are cases when highlights are *not* completely complementary to the colors they are on. Instead, they are relatively cooler or warmer in temperature to the colors they are on. Orange copper (the warmest color) has a pink highlight (pink is a cooler color than orange). Brass can have greenish yellow highlights (cool) on its slightly orangey-yellow (warm) basic brass color. Warm and cool colors are relatively complementary to each other. Highlights on flesh are also examples of ones that are just relatively complementary.

You can now see how important it is to always define the color of a subject as one of the six colors so that you will know what color to make its highlight. Therefore, a white vase has to be defined as some kind of colored white, a yellow, for instance, so violet can be used to make it look shiny. So-called black things also have highlights. Black hair is actually a very dark orange (a mixture of Burnt Umber and Alizarin Crimson into a dark gray of black and white). Its highlight would be orange's complement, a gray blue, made of black, white and blue.

Since metals are "shining examples" of highlights, they are the subject of this chapter.

The Colorful Metals

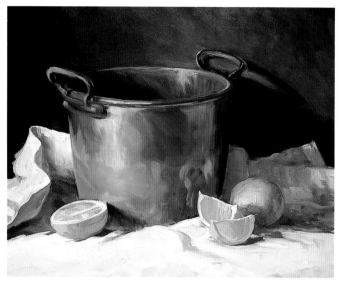

The tone of a highlight color must be in strong contrast to the tones that it is on. Never mistake copper's basic color to be the light tone of its highlight.

Cadmium Red Light and white on Burnt Sienna, Cadmium Red Light and white.

Cadmium Yellow Light and white on Cadmium Yellow medium and Burnt Umber.

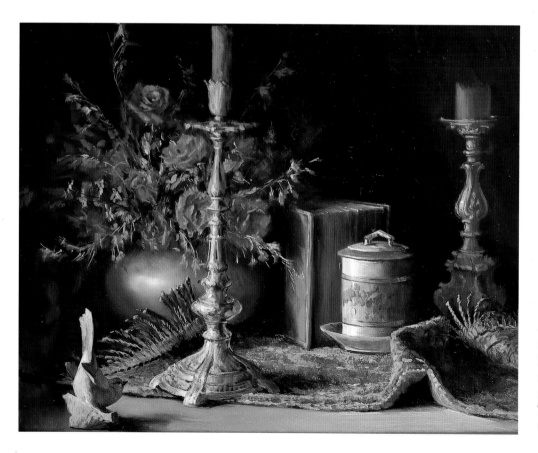

One light source causes one highlight to appear on **each concave and convex shape** of a metal object. The large candlestick has 28 shapes and 28 highlights.

The Colorless Metals

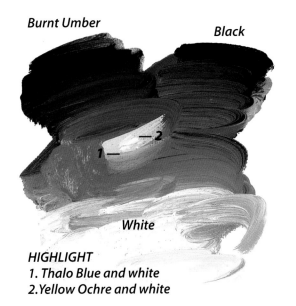

Burnt Umber

Black

White

HIGHLIGHT
1. *Thalo Blue and white*
2. *Yellow Ochre and white*

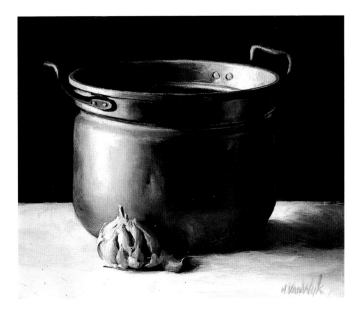

Highlighting a color can be done in three ways:

1. Piled on top of the body color.
2. Embedded into the body color.
3. Piled on in a somewhat large area and then cut down with the body color.

The procedure is determined by the type of highlight: little and sharp; fused in; or sharp with fused edges.

The highlights on these old cooking pots were embedded into the basic colors and then accented with a light tone. The aluminum pot belonged to my mother-in-law; I use it for soup. I suppose the iron pots were also used for soup, but they are before my time.

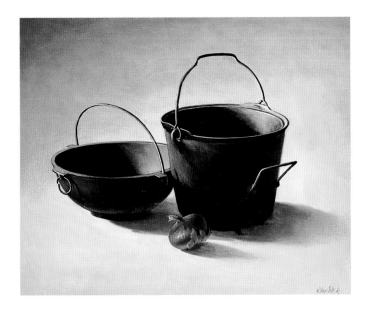

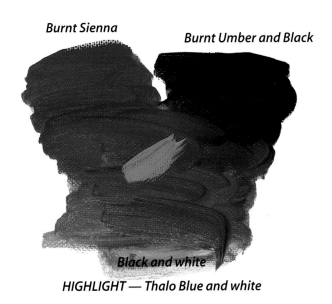

Burnt Sienna

Burnt Umber and Black

Black and white

HIGHLIGHT — *Thalo Blue and white*

Color Mixtures for Metals

	COPPER	BRASS	PEWTER	SILVER	IRON
Body Tone	Burnt Sienna, Cadmium Red Light, bit of black & white	Burnt Umber, Cadmium Yellow Medium	Black & white, Burnt Umber	Black & white, Raw Sienna	Black & white, Burnt Sienna
Body Shadow	Burnt Sienna, Alizarin Crimson, Thalo Blue	Thalo Blue & Alizarin Crimson into body tone	Add more Burnt Umber, Burnt Sienna, Alizarin Crimson & Thalo Blue	Add black, Alizarin Crimson & Thalo Blue to body tone mixture	Thalo Blue, Burnt Sienna, Burnt Umber
Highlight	white, Cadmium Red Light, Cadmium Orange	Cadmium Yellow Light & Medium into white & even lighter with Cadmium Yellow Light & white	White & Thalo Blue, lighter with white & Yellow Ochre	White, Alizarin Crimson & Thalo Blue. Lighten with white, Yellow Ochre	Black & white, Thalo Blue
Darker Reflections	Burnt Sienna, Burnt Umber	Alizarin Crimson & black	Burnt Umber	Burnt Umber	No reflections. Thalo Blue & Alizarin Crimson for darkened darks
Light Reflections	Cadmium Red Light & light gray (black & white)	Cadmium Yellow Medium	Colors that reflect into it mixed into gray (black & white)	Depends on colors surrounding silver	Gray-blue, the color that is influencing the iron
Cast Shadows	Cast shadow are complementary mixtures to the colors they are cast upon. Copper things don't cast blue shadows. A cast shadow from a copper pot on a yellowish-white cloth is violet. A cast shadow on copper from a lemon is bluish because the cast shadow is on the copper color.				

GLAZING WITH COLOR

Here is a way to understand glazing with color (or applying a glaze): Visualize a black-and-white photograph covered with a piece of red cellophane (or a red acetate sheet). All of the tones of the photograph would be in tones of red instead of in black and white. There, in a nutshell, is the process of glazing: the photograph represents a monochromatic underpainting; the transparent red cellophane acts as a glaze does.

Let's apply this illustration to glazing with paint. When most oil colors are thinned with any type of medium, be it linseed oil, a prepared medium, varnish or even turpentine, and applied over a pre-painted (and thoroughly dried) area, they form a coating much like the red cellophane did over the photograph.

Transparency is a characteristic of oil paint that few people know about, since the first and foremost image of oil paint is one of thickness and opacity. While there are certain oil colors that are classified as semi-opaque, the addition of a *medium* will transparentize them enough to be applied as a glaze. The addition of *white*

paint makes all oil paints opaque, even the very transparent ones like the Thalos and Alizarin Crimson. Colors mixed with white cannot be applied as a glaze.

Paint's transparency is useful as well as beautiful. Color glazed over a monochrome or other color is clear and luminous looking. A transparent glaze can add more color, or color correct an area. It can darken an area, even tone down a color as well as enrich a colored area.

To understand the valuable contribution that glazing can present, you must accept one essential factor about color and color mixing: the *correct tone of a color* determines two-thirds of its being a successful mixture. The tone of a color (how light or how dark it is) establishes a color's brightness or dullness as well.

The other third of color mixing success is relatively easy, that of adding to the tone and intensity the peculiarity of the color's hue.

This chapter on glazing will help you understand color and color's tone, and will surely add to your color mixing skill.

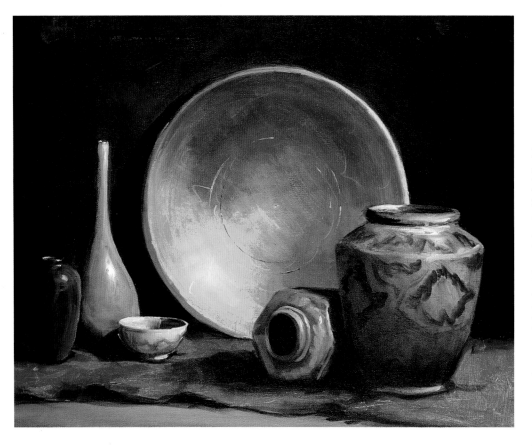

Glazing's Not a Mystery

Before glazing this picture on my television show, I had prepared, off camera, its underpainting in tones of gray: black and white acrylic paint thinned with water. The technique of glazing color onto an underpainting was more widely used four or five hundred years ago when tubes of color were not as easy to come by as they certainly are today. Underpaintings in those days were prepared with egg tempera, a water-based, fast drying medium. Acrylics are water-based and fast-drying, but there seems to be some question among certain people about the wisdom of painting oil over acrylics. I can only reply by wondering about the painters of the past. Did they worry whether their glazes of oil over tempera would ever survive future generations? As far as I am concerned, that's the only mystery about glazing.

It's Simply Using Transparent Color

In this chart, I painted little squares of color, thick enough to cover the canvas. I then painted a thinned down version of the color—a glaze—over a gray ranging from light to dark. This diagram clearly shows how a glaze of color is lightened by the light tone and darkened and dulled by the dark gray tone.

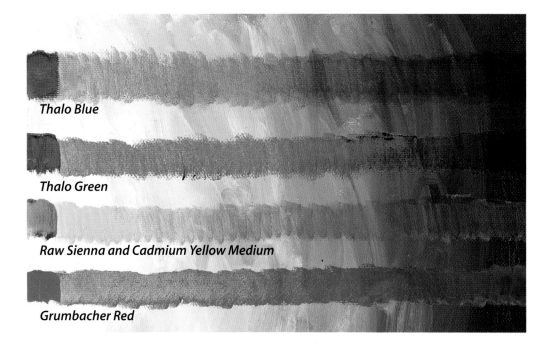

Thalo Blue

Thalo Green

Raw Sienna and Cadmium Yellow Medium

Grumbacher Red

Glazing in Action

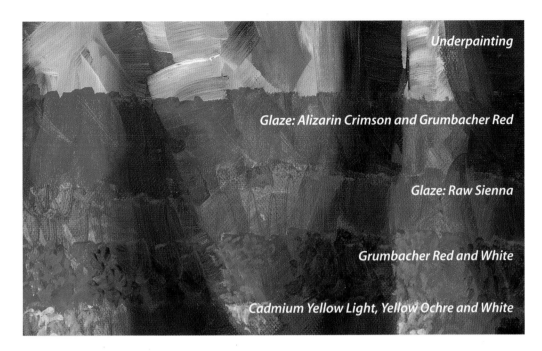

Underpainting

Glaze: Alizarin Crimson and Grumbacher Red

Glaze: Raw Sienna

Grumbacher Red and White

Cadmium Yellow Light, Yellow Ochre and White

I am sure that you recognize my old Holland cocoa pot (below). If you do, you can see how different it looks in this painting. The reason—it was started with an underpainting, as was the entire picture. The extremely complex texture of the old Dutch tablecloth dictated a necessity to use an underpainting-glazing treatment. I had to paint folds, I had to paint a thick, nubby texture, and I had to add a pattern of different colors as well. I did the tones of the folds with the underpainting. I added the colors of the rug with glazes, and finally added little dots of lights and darks with opaque paints for its nubby texture.

What Underpaintings Look Like

▲ I use an underpainting in my portraits to establsh the size and placement of the head, a simplified rendition of the lights and darks on the face, the tone of the background, and the clothing.
(Self portrait on page 117)

▼ When painting outdoors, I simply wash in the basic tones, usually sky, middle distance, foreground and focal point. (Landscape on page 124)

An underpainting is a foundation coat of paint that adjusts the painting surface to make the actual painting process easier to do. An underpainting can be used as a preliminary step for landscape, still life, portrait, in fact, any type of picture. Sometimes it can be the vaguest suggestion of a composition; other times, a more elaborate rendering. An underpainting has to be thinly applied, with the texture of the canvas clearly in evidence. Oil paint is not an adhesive; it only adheres to the rough tooth of the canvas. Consequently, don't paint underpaintings smooth and thick.

The three underpaintings, shown here, epitomize the various extents of the tonal rendering I do to prepare for the glazing technique.

▲ My still life underpaintings are defined but not detailed. (Still life on page 106)

I call my underpaintings my pictures' security blankets.

BUILDING COLOR WITH BRUSHWORK

Application of color mixtures has a strong bearing on the way color mixtures look. Brushwork can make color mixtures look exciting and vibrant and, unfortunately, sometimes make color look dead. There is a basic, reliable type of brushwork that gives your color mixtures an advantage. It is that of applying colors in opposing stroke directions instead of applying colors in all the same direction of strokes. The opposing strokes of color can be set down next to each other or on top of each other. They can also be used to blend in areas of color. A combination of opposite brushstrokes instills some identity and character into the paint. Painting an area of color with opposing strokes excites the color. Blending color areas by using opposing strokes fuses the color, leaving slight variations of the color's intensity which seems to impart a more vibrant color presentation than an area that has been completely blended in.

You have learned that balance is as important in painting as it is in nature and how opposites can strike that balance, as in:

- Colors and their complements are opposite
- Warm and cool colors are opposites
- Light and dark are opposites
- Bright and dull are opposites

Now, I've introduced another balance, that of brushwork. Opposing strokes respect the dictates of nature's balance. Doing so serves a more practical, less erudite, purpose. It helps to fashion dimension: One direction of application—one dimension; two directions of application—two dimensions. Use contrasting tone and the feeling of the third dimensional effect is yours.

Strokes of Color Next to Each Other

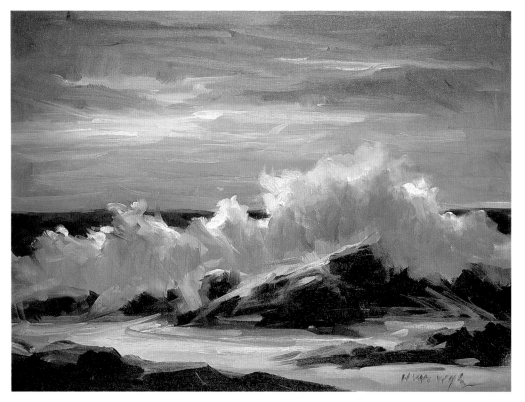

Try to think of your canvas as a surface that is going to support the paint you will use to record your subjects rather than a surface to be covered with your paint. Doing so will make your brush begin to excite your paint with dimension. Here, in a diagram of the brushwork I used to paint an ocean wave, you can see a suggestion of dimension.

Strokes of Color on Top of Each Other

The textures of many subjects are quite complex. An obvious example is the layers of translucent skin of an onion. Painting its texture and its round shape well can be done with layers of opposing brushstrokes. Try to translate the elements of a subject's complexity in terms of brushwork and layers of paint. The sum total will record a subject's appearance.

25

THE COLOR OF FLESH

There is a large group of people who reserve a special kind of awe for portrait painters, holding them in far more esteem than they do for the painters of pots, vases, fields and streams. Probably responsible for the elevation of the portrait painters to this niche on Mount Olympus is the mystery of capturing a likeness, making mere paint record skin that looks alive, depicting eyes that follow the viewer all around the room, and portraying mouths that might even speak.

Many students think the difficulty of portrait painting is in mixing flesh colors. Actually, flesh colors are quite easy to mix. Basically, they are yellows, oranges and reds mixed into white or into gray. You'll find many yellows, oranges and reds in paint: all the cadmium colors and all the earth colors, ranging from bright to dull, from light to dark. All *you* have to do is look at the model's skin and match it. But, Ho! Ho! Ho!, there is much more than the flesh color to consider. You have to be aware of other factors to orchestrate in order to paint a portrait and get a likeness, such as:

1. The placement and size of the head.
2. The proportions of the features of the face: the forehead, eyes, cheeks, nose, mouth, chin. All have to

be observed and carefully painted in proper proportion to each other.
3. The perspective at which you look at the features.
4. The choice of the tone and color of the background that will be suitable to the model's hair, skin and manner.
5. The correct shape of the contrasting tones of the flesh colors.
6. The coverage and character of the paint on the canvas.

All these elements have to be executed with color mixtures. So even though flesh colors are easy to mix, flesh colors in action are difficult. There is still another difficulty that is only peculiar to portrait painting. Portraiture is a joint effort. You need your model's patient, endorsing cooperation.

This chapter concentrates only on the colors of flesh not on the art of portrait painting. That's a book of its own! No matter *how* many books you read on painting, none of them can substitute for hours and hours of practice. Books can, however, direct you to practice the right way. It takes just as long to paint badly as it does to paint well.

A Close Look at Eyes

The whites of the eyes are not white. *Even the highlights in eyes are not white. The whites of eyes are the model's basic flesh color lighted a bit with a gray made of black and white. The highlight is a very light, warm gray (black, white, Yellow Ochre).*

I used the same lighting for both these portraits. Notice how a similar shadow pattern falls on our features, describing our likenesses. The detail of the eyes shows how simple light and dark shapes combine to form the most complicated features of the face.

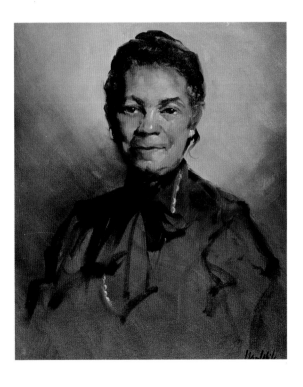

Every Flesh Color is Different

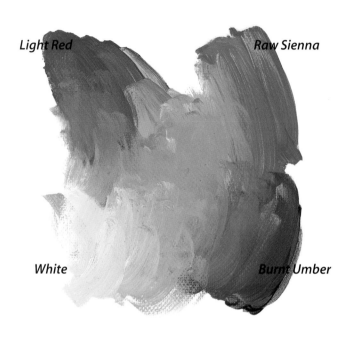

Light Red

Raw Sienna

White

Burnt Umber

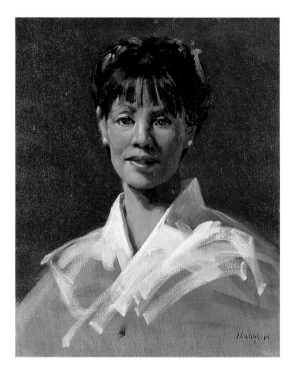

Slight variations in color mixtures will breath some life into flesh colors. In the color swatches you can see how the colors and white are moved together rather than mixed completely. Don't mix up one big puddle of one flesh color and especially don't do it with a palette knife. Overmixing deadens a color; whereas colors that are quickly eased together on a palette will radiate with vitality on the canvas. This is why you should use a soft, malleable type of white paint, not thick and heavy.

All Flesh is Color into White

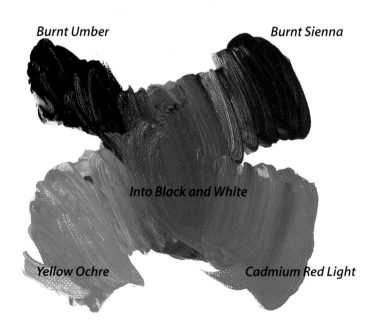

Burnt Umber

Burnt Sienna

Into Black and White

Yellow Ochre

Cadmium Red Light

Possible Flesh Mixtures for the 5 Basic Tones

1. **Body Tone.** Move a big gob (teaspoon) of white into the mixing area of the palette. Into a corner of it add Yellow Ochre and some Cadmium Red Light. Move more bright yellows and bright red, as needed, or duller warm colors, such as Burnt Umber, Burnt Sienna into the puddle. Don't be afraid to make this mixture colorful. The first application of the body tone should be strong enough in coloration to withstand a subsequent lightening. Your paint mixture shouldn't be thin and runny. You'll know it's a good consistency if you can't see the color of your palette through it. This mixture can be spread on the canvas by the dampness of your brush.

2. **Body shadows.** Near the flesh puddle on your palette, mix some Sap Green, black and Alizarin Crimson in a dark tone that contrasts the tone of the flesh mixture.

3. **Cast shadows.** Darken the body shadow mixture with Burnt Sienna and a touch of Thalo Blue.

4. **Lighter Body Tones.** Into a new gob of white add amounts of warm color, such as Cadmium Yellow Light, Cadmium Orange, Cadmium Red Light.

5. **Highlight.** Add a little Cadmium Yellow Medium and Alizarin Crimson to white making a very light tint. Work this mixture into the flesh on the planes of the face that seem to shine.

6. **Color in the shadows.** Into the shadow mixture add a touch of white, Raw Sienna and Light Red.

7. **Reflections.** Add a touch more white into the color-into-shadow mixture plus any color that seems to be influencing or reflecting into the shadows.

8. **The darkest dark.** Mix Burnt Umber, Alizarin Crimson and a touch of Thalo Blue into a corner of the shadow mixture for nostrils, corners of the mouth, and shadows on the eyes from the upper lids.

These mixtures are merely a guide, not guaranteed to record a person's flesh colors. People's skins not only vary in color but in texture as well. Add to these variations different lightings, such as soft, flattering, strong, or harsh. Don't be tempted to paint babies from photographs; their skin is too delicate and their likeness too fragile. This kind of challenge is too hard to meet without some experience gained from working on more substantial models.

Flesh in Light Flesh in Shade

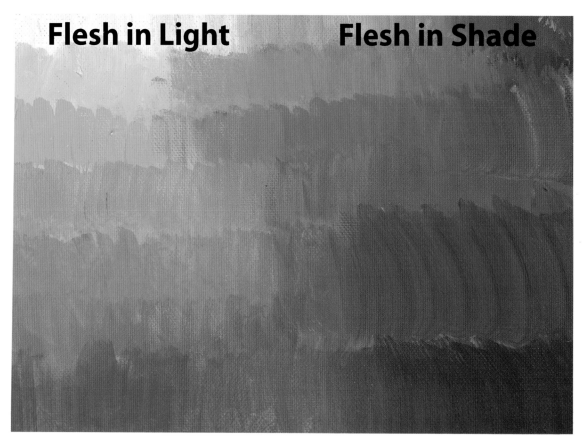

The light flesh mixtures are yellows and reds mixed into white. The shaded tones are the same yellows and reds mixed into gray.

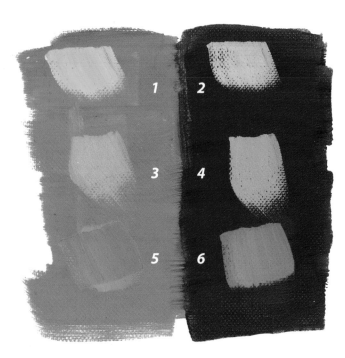

See how the different background tones can change the appearance of the very same flesh mixture. Yes, it's hard to believe that 1 and 2 are the same flesh mixtures, as are 3 and 4, 5 and 6.

Don't overwork flesh mixtures, especially when painting children. Try to be accurate with shapes and colors per stroke.

Looking for Lighting Instead of Likeness

I painted this self portrait back in 1961, when I was young (I wonder if I really looked that innocent). The painting makes me appear to be right-handed since I'm holding my palette in my left hand. Those that have seen my TV show know that I am left-handed. Because I look at myself in a mirror to do a self portrait, I see my reflection in reverse. I painted this self portrait in a studio lighting condition used so often by portrait painters. I've seen it in paintings by Rembrandt, Rubens, Hals and David, to name a few. My light body tone is shaped by the dark background on my left. The shadowed part of my body is shaped on the right by the lighter background tone. My cast shadow falls over my palette and onto the background. This is a humanized rendition of the basic values illustrated on page 90.

I painted this self portrait in 1985. Older, of course, I disguised my age by putting my face all in shadow. It wasn't vanity that made me use this lighting; it was provoked by a conversation I had with a man who was posing for his portrait. I explained to him that I was looking at the lighting on his face, and asked him whether he could see any lights and darks on my face. "No," he said, "your face is entirely in shadow." After he had left, I was curious about what he had said. Using a mirror to see what he had seen, I found the lighting to be so intriguing that I set up a canvas. The white of the bare canvas reflected into the right side of my shadowed face making the lighting effect even more interesting.

A Color Recap

By now, you may be tired of my constant reference to the object's **color being in light and shade**. I must emphasize and impress upon you that it is the light you see on a subject's color not its very own color.

I hope these "odd couples" (pairs of totally unrelated objects) will help you come to the conclusion that, "I'm beginning to see the light and dark."

Color Mixtures for	their colors	in light	in shade
Dirt roads Dirty blondes	Yellow Ochre, Burnt Sienna, Burnt Umber	Into white	Into black, white, Alizarin Crimson
Red lips Old red barns	Cadmium Red Light, Light Red	Into white	Into Sap Green and Alizarin Crimson
Teeth Gray hair	Raw Umber	Into light gray of black & white	Into Thalo Blue and Alizarin Crimson
Mahogany tables Brunettes	Alizarin Crimson, Burnt Umber, Burnt Sienna	Into light gray of black & white	Into Thalo Blue
Green grapes Sunlit grass	Thalo Yellow Green, Raw Sienna	Into white	Into Manganese Violet
Pewter Fog	Thalo Blue, Burnt Sienna	Into light gray	Into dark gray of black & white
Lemons Daffodils	Cadmium Yellow Light, Yellow Ochre	Into white	Into Manganese Violet

The fact that these odd couples' color mixtures could be the same may lessen your anxiety about getting the right color of your subjects, thus freeing your attention to focus on an object's shape.

THE COLOR OF LANDSCAPES

Many people try their hand at painting only to quit because they find it too frustrating. Surprisingly, lack of talent isn't what drives them from the easel; their frustration seems to stem from their inability to accept the difference between reality and paint. Students of painting suffer from this problem, too, when they believe they have to make a tree out of leaves instead of paint, and think a brush can actually bring the sky down onto a canvas. Once they realize that the *look of the paint* is the only way to recreate the subject, they will have conquered the major frustrating part of painting.

From the look of my paintings, people have conjectured that I paint well because I am a perfectionist. Absolutely not! Perfectionism in painting is too frustrating. I only try to make the "best of it." The best of what paint can be and what paint can do. Paint can't be the tree or the sky; I translate them with brushstrokes of paint, mostly in a layer that more than adequately covers the canvas. I make mixtures of bright or dull colors that are either light or dark and, by a well-thought-out procedure, I make the contrasting tones fit together to record the shapes of the composition.

I'm frustrated, all right, but my frustration is not about painting; it's the pressure of not having enough time to paint. I overcome this by being well organized with my time, practical with my procedures and efficient with my materials.

For those few times that I get out of my studio to paint landscapes, I have some medium-toned gray canvases on hand in sizes from 9 x 12 to 18 x 22 inches.

The changing light outdoors adds to my pressure of time; I can only work for about two hours, making a canvas larger than 18 x 22 more ambitious than practical. A toned canvas (prepared with acrylic gesso toned with black or violet) is easier to paint on than a white one. I can lay in light patterns of color and immediately see their shape and effect as they contrast the gray tone of the canvas.

I don't load my French sketch box easel with a lot of stuff I don't need. I make sure I have a lot of white paint, and scale down my palette to the colors that I use outdoors: Cadmium Yellow Light, Thalo Yellow Green, Cadmium Red Light, Grumbacher Red, Yellow Ochre, Raw Sienna, Light Red, Burnt Umber, Burnt Sienna, Sap Green, Thalo Blue, Alizarin Crimson, Thalo Green and Ivory Black. Five brushes, rags and a large container of medium (made of five parts turpentine, one part linseed oil) round out my equipment. I use this medium for cleaning my brushes between mixtures and wetting my brush to help spread the paint.

I always set my easel up to hold my canvas in shade. The tones of color mixtures set down on a sunlit canvas are hard to judge and hard on my eyes.

Our visits to Italy are never long enough for me to paint on location. I have to resort to working from my photographic references back in my studio in Rockport. I refer to them to recall my actual visual inspirations, which leads me to clarify a point that's raised in many letters that I receive. In the question of originality, your own photographs are as legitimate as your actual subject matter. When working from photographs or pictures other than your own you should consider them as copies and qualify them as such, with the appropriate credit to either the artist or the photographer.

Cape Ann Themes

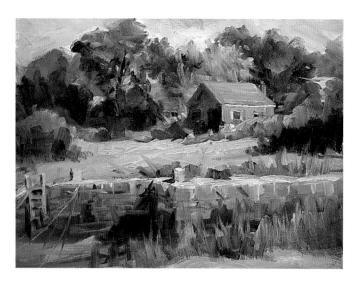

Lanesville is a little town on Cape Ann. Views of its harbor have provided artists, from well known professionals to aspiring students, with refreshing ideas for paintings. Early morning, late afternoon light offer wonderful contrasts to seemingly uninteresting vistas. This little old shack is used for fishing gear; it is outfitted with a stove and an easy chair for the fishermen to wait for the tide, I would guess. After I placed the composition (off center, of course), I proportioned all its surroundings to it. My main area of concern: the tone of the distant trees in relation to the light on the sand of the middle distance, the top plane of the stone pier and its shadows.

I did **Boats** on one of my television shows to teach how to paint reflections in still water. This is another example of a complex texture-reflections into the water and the surface of the water. I relied on two directions of paint application: the tones of the reflections in down strokes; then across strokes to suggest the ripples. I worked from a black and white photograph as a reference. This subject and foggy days are familiar to anyone who lives on Cape Ann.

The Bridge at Good Harbor Beach is the center of interest in this picture, principally the bridge's footing on the left. I began this picture by placing and sketching the bridge just to see how it looked. My drawing of it was almost entirely obliterated by my painting process, especially the colors of the marsh and water behind it. An initial sketch is not a drawing to be filled in with paint. It's a linear indication or, shall I say, a pictorial memo to yourself of things to do with paint.

Italian Themes

A View of Florence. I was inspired by the early morning misty light on the city in contrast to the light on the small country monastery. I saw this vista on our way to Rome, and even though we were anxious to proceed on our trip, we turned back so I could take some pictures.

Roman Rose Garden. I found this composition as we walked along the Tiber River. There really was only one rose blooming—I added more to add interest; besides, one looked too lonely.

La Principessa is a lovely 18th century villa near Lucca. Now a hotel, its gate in the wall is one of many around the vast, beautiful grounds and gardens. Picasso had his "blue period"; this painting is one from my "gate period."

Helpful Hints About Color in Landscape Painting

1. The Shack in Lanesville. The red roof surely added the interest that this predominantly green composition needed.

Distant trees: For various greens, use Thalo Yellow Green and black and white; Sap Green and black and white; Alizarin Crimson, Burnt Umber and Thalo Green and black and white.

House roof: White, Cadmium Red Light and Yellow Ochre.

House: Burnt Umber and white; Thalo Blue, white and Burnt Umber for its shadow.

Sandy road: Yellow Ochre, Burnt Sienna, black and white.

Top of stone pier: White and Yellow Ochre.

Side of stone pier: Black, white, Burnt Umber, Burnt Sienna and Raw Sienna.

Shadow on stone pier: Black, white, Burnt Umber, Alizarin Crimson and Thalo Blue.

Foreground grass: Thalo Yellow Green, white and Sap Green.

2. Gloucester Boats. Bright important colors are assets only to the focal area.

Sky, water and fog: White, Thalo Blue, Yellow Ochre and Burnt Umber. Paint these mixtures in from the sky to the bottom of the canvas. With a rag, wipe away the paint so you can do the boats.

Boat cabin: Cadmium Yellow Light, Yellow Ochre and white; a shadowed side gray and Raw Sienna.

Boat hull: Sap Green, black, white and Burnt Umber.

Red water line: Grumbacher Red and Alizarin Crimson.

Sailboat cabin: Thalo Blue and white, shadowed with gray.

Sailboat hull: Light gray and Yellow Ochre.

Shadow side: Black, white, Thalo Blue and Raw Sienna.

Reflections in the water: Repeat the boat's color in downward strokes, and then with some across-strokes ripple the water. Add all the rigging last.

3. The Bridge at Good Harbor Beach. A simple, good landscape composition is one with a well-defined distance, middle distance and foreground.

Sky: Cadmium Orange and white; Thalo Blue and white.

Distant Mountains: A gray of black and white, Burnt Umber, Sap Green and Alizarin Crimson.

Distant field: Thalo Yellow Green and white.

Marsh sand: Yellow Ochre and white; Raw Sienna and white.

Water: Thalo Blue, black and white.

Light tone of water: Thalo Blue, white and Yellow Ochre.

Bridge: Burnt Umber and Burnt Sienna greatly thinned.

Bridge footing—light tone: Burnt Sienna and Thalo Blue.

4. View of Florence. Don't be enslaved by a photograph by painting its details and its mistakes in composition. When working from a photograph, omit, move, accentuate, diminish! Be a creator not just another copier. I focused attention on the little monastery by contrasting its light tones with dark trees. If I hadn't diminished the tone and details of the dome in the distance, I would have ended up with two focal points.

5. Roman Rose Garden. Whenever one of my compositions has a large area of dark tone I do an underpainting. I think transparent color glazed over a dark tone looks more luminous than a thick, dark coat of opaque paint. A medium gray tone for the building was colored with glazes of Raw Sienna and with Burnt Sienna. The darker shadowed areas of the building were added with glazes of Manganese Violet and Burnt Umber.

6. The Gate at La Principessa. The three landscape planes in this painting are light distance, dark middle distance (the gate and trees) and the medium-toned foreground. Again, red came to the rescue.

The lights on the red wall: Light Red and white; Yellow Ochre, Cadmium Red Light and white.

The darks on the wall: Black, white, Light Red, Sap Green, Burnt Umber and Alizarin Crimson.

Paintings by Helen Van Wyk

18. TV/Study of White, 14 x 18
 Eggshells, 9 x 12 *
 TV/Green Bottles, 9 x 14
 Little Green Apples, 12 x 14
19. Roman Monk, 5 x 7
 Sheila Nemes, (Mrs Charles), 20 x 30 *
20. Melissa McDonald, 20 x 24
 Baskets, 20 x 24
 Feeding Pigeons, Verona, Italy, 14 x 18
21. Still Life With Strawberries, 20 x 24
26. Pears, 20 x 30
30. Statue in Bargello, 9 x 12 *
34. Vitamin C, 12 x 24
36. TV/ Apples, 12 x 16
 Basket of Apples, 16 x 20
37. Still Life With Lobsters, 12 x 16 *
42. New England Theme, 20 x 24 *
46. Geraniums, 20 x 24
50. Tuscan Pottery and Pears, 16 x 20
54. A-Tisket, A-Tasket, 30 x 40
58. Old Books, 16 x 20
 Dutch Tablecloth, 20 x 30 *
62. Hand-woven Shawl, 20 x 30 *
66. Onion Skins, 12 x 16
68. Silver Pitcher With Peaches, 18 x 24
69. Electric Bill, 36 x 40
76. Old Bowl With Peaches, 18 x 24
77. Rachel Dole, 20 x 24
 Fiesole Pitcher and Oranges, 16 x 20 *
80. TV/Landscape Composition, 14 x 18
 Essex Cemetary, 14 x 18 *

81. Morning Light in Gloucester, 16 x 20
84. TV/Pewter Tankard, 14 x 18
 Still Life With Fruit, 22 x 28 *
85. Misty Shore, 12 x 16
88. Borghese Pauline, (Pauline Bonaparte by Canova), 14 x 18 *
89. Daphne and Apollo, (Statue by Bernini, Borghese), 12 x 16 *
92. TV/Composition Lesson, 14 x 18
 The Capitoline Museum, Rome, 11 x 14
93. Ketchopulos Market, Rockport, 20 x 24
 Blueberries, 20 x 24
94. Daisies, 22 x 28
 My Birthday Daisies, 22 x 28
95. Summer Fruit, 18 x 24
 Concord Grapes, 14 x 24
96. TV/Silver and Roses, 14 x 18
97. Tansy, 9 x 12 *
 Roman Friar, 6 x 10
 Linda, 20 x 24
98. Nancy's Roses '89, 18 x 24 *
 Daffies, 12 x 16 *
100. TV/Drapery Lesson, 14 x 18
 Flowering Quince, 20 x 24 *
101. Covered Vegetable Dish, 20 x 24
102. Madonna and Child, Trompe l'oeil copy of the Della Robbia Ceramic, (Bargello, Florence), 18 x 24
106. TV/Copper Cooking Pot, 14 x 18
 Bird, Book and Candle, 16 x 20 *

107. Old Aluminum Pot, 12 x 16 *
 Old Iron Cookware, 24 x 30
110. TV/Glazing Lesson, 12 x 16
111. Holland Things, 20 x 30
114. TV/Atlantic Surf, 18 x 24
115. Onions, 16 x 24 *
117. Self Portrait '89, 20 x 24
 Bonita Valien, (portrait demonstration), 20 x 24 *
118. Oriental Lady, (portrait demonstration), 20 x 24
 Frank Wilbright, (portrait demonstration), 20 x 24
120. Josh Mears, 12 x 16 *
121. Self Portrait '61, 24 x 30
 Self Portrait '85, 20 x 28
124. Lanesville, Gloucester, 12 x 16
 TV/ Boats, 14 x 18
 The Bridge at Good Harbor Beach, 14 x 18
125. View of Florence, 20 x 24
 Arched Rose Garden, 11 x 14
 La Princepessa Gate, Lucca, 16 x 20

* Denotes Private collection

TV denotes demonstration for TV series

Index